BERLIN

New Architecture

A guide to new buildings
from 1989 to 2002

November 1, 2002

Dear Charlie,

It is much fun to discover the
new architecture in Berlin, but also
the amazing Berlin Philharmonic hall, the
Jewish museum, the many train stations,
not to mention the lively cultural scene.
Berlin has wide streets and sprawls for miles,
unlike Paris.

All the best,

Norbert

Michael Imhof and León Krempel

BERLIN

New Architecture

A guide
to new buildings
from 1989 to 2002

MICHAEL IMHOF VERLAG

Michael Imhof/León Krempel:
Berlin. New Architecture.
A guide to new buildings
from 1989 to 2002,
2. edition Petersberg 2002.

translation:
Alexandra Gärtner
Peter Norwood
Stefanie Woyth-Gutberlet

photos:
Michael Imhof/
León Krempel
p. 64: © Eller & Eller,
Düsseldorf/Wasmuth, Berlin

© 2002 (2. edition)
(1. edition 2001:
M. Imhof/L. Krempel:
Berlin. Architecture 2000.
A guide to new buildings
from 1989 to 2001)

Michael Imhof Verlag
Stettiner Strasse 25
D-36100 Petersberg
Tel. 49(0)661/9628286
Fax 49(0)661/63686

Design/reproduction:
Michael Imhof Verlag
Printed by Meiling Druck,
Haldensleben, Germany

Printed in EU

ISBN 3-935590-15-6

Introduction

Today, in the thirteenth year after the fall of the wall, Berlin is still the largest construction site in Europe. The city is, however also a great deal more than that, and it now fulfills its role as the capital of a reunited Germany in a manner that should make you think it has always been that way.

Within less than a decade the government and its ministries have taken up residence here, where they were joined by embassies and associations. Whole city districts have changed their appearance and their composition, innumerable buildings have been restored, rebuilt, or erected – a most astonishing change has taken place. Berlin is more than ever worth a journey. A selection of the new buildings that have been completed by now is presented by this guide in words and pictures.

Berlin architecture after 1989 can hardly be understood without looking at the way postwar-history has left its mark on urban planning in the city. After the end of World War II most parts of Berlin, particularly in the city center, had turned into expanses of rubble. Three quarters of the city's apartments had been destroyed or were not immediately rehabitable. The number of inhabitants, many of whom were refugees, had dropped from 4.33 million before the war to some 2 million. This "tabula rasa" provoked bold outlines of urban planning, which, for reasons of land ownership alone, could not be implemented, but had a stimulating effect on the future. The best-known outline, the "Kollektivplan" (collective plan), drawn up under the leadership of Hans Scharoun in 1946, conceived city greens and a less monotonous city-scape following the course of the River Spree like a ribbon, with a network of junction-free motorways. With the Marshall-plan, which was

signed by the occupying powers except for the Soviet Union in 1948, the reconstruction in the sectors controlled by the Western allies obtained its political foundation. The blockade of West Berlin (1948/49) and the foundation of the GDR with East Berlin as its capital further fuelled the process of division, which was founded on ideology and reached its sad nadir in the construction of the Berlin Wall (1961).

In the two parts of Berlin entirely different concepts of urban development were pursued, and it even came to an open competition between the two halves of the city. The government district of the GDR was to be built in Berlin's historical center on the Spree island. By the end of the year 1950 the city castle, which had been damaged in the course of the war, was pulled down and its site first served as a marching ground. Following the example of Soviet-Russian cities an excessively wide axis was laid through East Berlin, leading from Brandenburg Gate across Alexanderplatz to the newly built Stalinallee with its monumental blocks of apartment buildings called "workers' palaces". With their walkout, construction workers in the Stalinallee triggered off the GDR-wide general strike which was to go down in the annals of history as June 17, 1953.

Although the process of reconstruction in West Berlin didn't take place as forcibly as in the east, the city scape underwent no less of a transformation. While the former was first dominated by a neo-classical national style, the latter was characterized by attempts to take up the tradition of the architecture of the Bauhaus, which had been interrupted by dictatorship and the war – unless architects succumbed to the "Nierentisch-Mode", the style of the kidney-shaped table, which had just become fashionable. The parade streets in the East were countered by the West

Berlin Senate with the concept of a ring of urban motorways according to the American example. The first stretch of the urban motorway between Halensee and Hohenzollerndamm was opened in 1956. The reconstruction of the Hansaviertel (Hansa district) at the western fringe of Tiergarten, which had been severely damaged in the war, was perceived as a unique opportunity to create a counter-example to the expanding Stalinallee. In accordance with a decision by the Berlin Senate of 1953, when a first competition of ideas was already in progress, the International Exhibition of Building and Construction was held there in 1957 with the participation of renowned architects like Alvar Aalto and Walter Gropius. The different trademarks of the architects, who nevertheless subordinated themselves to a common concept and who were committed to a modern architectural style, as well as a less monotonous manner of construction with multi-storey buildings and low detached family houses merging into the scenery of Tiergarten, were meant to express political values like liberty and pluralism. In addition the Federal Government and the Berlin Senate announced an international competition of ideas, "Berlin, the capital", which provocatively ignored sector boundaries, since it started from the assumption that Germany would be reunited. This was in turn answered by a "competition of ideas as to the socialist remodelling of the capital of the GDR's center, Berlin", announced in 1958. It had been preceded by a model outline drawn up by the collective Kosel, Hepp, and Martins suggesting a city-center in the form of a high-rise building as the seat of the government.

If compared with the contributions to the competition, some of which would have changed the city-scape drastically, the new layout of the center of (East-)Berlin as actually carried out was comparatively moderate. The buildings housing the State Council of the GDR (1962) and the Min-

stry of Foreign Affairs (1963-66, torn down in 1995) were constructed, around the castle square. This was also the site of the Palace of the Republic (1974-76), which, as the seat of the People's Congress and as a public center of leisure activities, was to become a symbol of the GDR's adaption of a more popular touch. After a long period of planning, the center building was finally integrated in the television tower at Alexander Square (1965-69). Stylistically, the architecture in East Berlin was approaching a modern use of forms – the differences if compared with the architecture in West Berlin, which had been so distinct in the beginning, were getting less and less. A particular feature of the East remained the "Plattenbauweise", the building of monotonous apartment blocks made of concrete slabs – a consequence of the industrialisation of the building and construction sector called for at the first building conference in 1955 and tested in 1959 throughout a residential area on Prenzlauer Allee/Ostseestrasse for the East of the city and the republic – with the familiar effects.

In West Berlin the Kulturforum (Cultural Forum) had been developing since 1960, which may be regarded in a way as a legacy of the Cold War as regards urban development, and which is of importance in terms of architectural history, since all major trends of the post-war period can be studied in it like in a pattern book. It was built as a substitute for the Museumsinsel (Museum Island), the world-famous ensemble of museum buildings, which had been allocated to the eastern part of the city, not far from the wall in the middle of a piece of wasteland where posh villas used to be located before the district was blown up to make way to the north-south ring road planned by Albert Speer. In anticipation of the future reunification of Germany, however, it was considered a part of a "cultural bond" extending beyond the borders with locations around the Charlottenburger Schloss

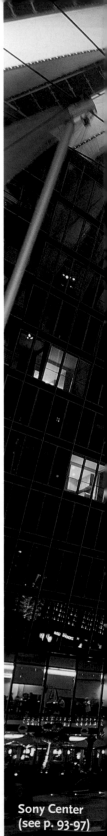

Sony Center
(see p. 93-97)

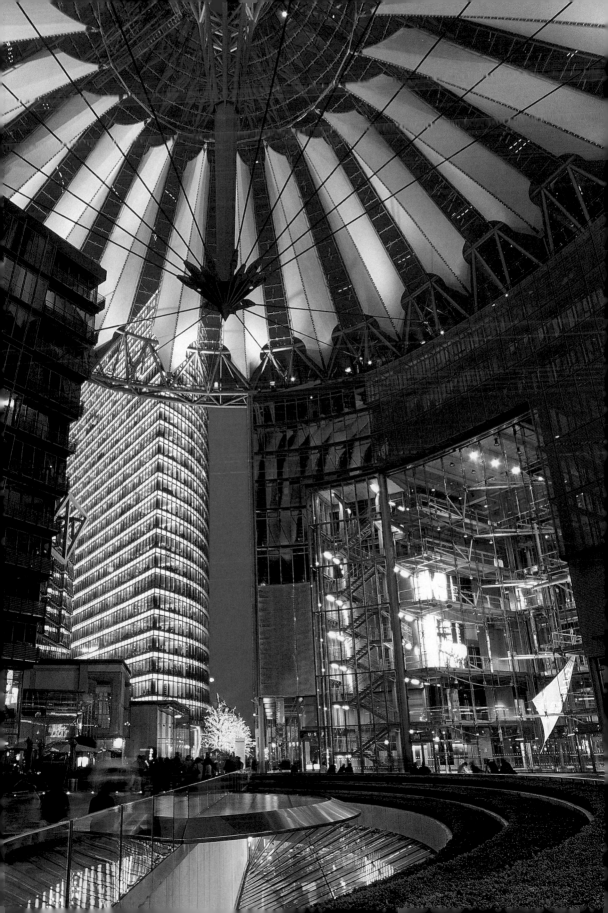

(Charlottenburg Palace) and the Museums-insel itself. The concentration of cultural buildings in one place, their loose arrangement, and the scenery corresponded to the vision of urban development that Hans Scharoun had, to whom the overall concept, which had been revised several times, is attributed, and who – with the Philharmonie (Philharmonic Hall, 1960-63) and the Staatsbibliothek (State Library, 1966-68) – created two of the most splendid buildings of the 20th century in Berlin. The Neue Nationalgalerie (New National Gallery), the only work by Mies van der Rohe undertaken in Germany after the war and the city's second most important museum building following the Alte Museum (Old Museum) by Schinkel, was built in the interim between the construction of Scharoun's buildings (1965-68). The Rolf Gutbrod`s designs for the Kulturforum combined Scharoun's tradition with the styles of brutalism and structuralism, which had been gaining ground since the 1960s.

Following initial plans in 1966, Gutbrod's Kunstgewerbemuseum (Museum of Arts and Crafts) was not carried out until 1978-85, when it no longer satisfied the latest museological requirements. It was therefore criticized so vehemently that the Stiftung Preussischer Kulturbesitz, for whom the museum had been built, withdrew the commission to continue the planning of the area from the architect. Consequently, the other buildings that he had started to build, the Kunstbibliothek (Arts Library), the Kupferstichkabinett (Copper Engraving Collection) and the Erschliessungs-halle (hall) with the "Piazza" in front of it remained unfinished.

In the meantime, with the Wissenschafts-zentrum (Centre of the Sciences) a highlight of postmodern architecture was built in Berlin by James Stirling and Michael Wilford (1984-88). Heinz Himmler and Christoph Sattler were commissioned for the Gemäldegalerie (Picture Gallery) and for "improving on" the buildings by Gutbrod. With their conservative approach to the gallery they appeared to be changing the course back towards a more classical style, as if Mies meant more to them than Scharoun for the Kulturforum. However, in a typically postmodern manner they actually enriched the building (1988-98) with their unconventional interpretations of architectural quotes.

Other architectural developments in Berlin since the 1960s can only be briefly described in a survey: In the Western part of the city mass housing schemes like Gropiusstadt (1962) and Märkische Viertel (1963) did not particularly improve the housing conditions in the growing city districts. In 1968 first protests against property speculations were voiced, followed by the occupation of houses from 1979 to 1984. Over a long period of time the great number of building scandals contributed to the negative image of a subsidized provincial town. Those new buildings worth mentioning appear stylistically inconsistent, yet this impression may be put down to a lack of temporal distance. The Moloch of the International Congress Center (1973-79) can roughly be compared with the Centre Pompidou in Paris. Less well-known but of greater importance in times to come was the residential area "Block 270" by Josef Paul Kleihues (1975-77) in Vineta Square in Wedding, the first block-style building area which respects the traditional alignments in Berlin after World War II and an early example of cautious city redevelopment. After all, the density of the city, which had been increasing since about 1970, hardly permitted further architectural extravaganzas – individual solutions were now asked for instead.

The resurrected type of the "city villa" challenged the architects' creativity. Imaginative and unconventional outlines had good prospects of becoming implemented, like the residence buildings by Hinrich and Inken Baller or the motorway superstructure Schlangenbader Strasse (1976-82). The 1980s were dominated by

the International Building Exhibition. Decided by the Senate in 1978 and originally planned for 1984, it was not held until 1987, the city's 750th anniversary. Not only were countless buildings drawn up for this occasion – some of which were only completed later – but important theoretical stances, which could be relied upon after the fall of the wall, were formulated as well. The IBA for new buildings, which was headed by Josef Paul Kleihues and included the areas southern Friedrichstadt, southern Tiergarten, Prager Platz and Tegel, recommended the principle of a "critical reconstruction", according to which historical rules like block margin development and a prescribed eaves height should be obeyed for the sake of a consistent city scape without copying decorative details. The IBA for old buildings, headed by Hardt-Waltherr Hämers, with Kreuzberg as its competition area, took into account the needs of the tenants as well as the preservation of historical monuments by promoting the principle of "cautious urban development".

In the eastern part of the city housing problems, i.e. mainly the standstill in renovations, became apparent only after the fall of the wall. The preservation of old buildings was neglected in favour of new buildings. The satellite town of Marzahn, initiated on in 1975, was meant to create new living space for thousands of people all at once. The modernization of the Nikolaiviertel, whose completion was celebrated on Berlin's 750th anniversary by the GDR, only ostensibly represents an exception, since it wasn't carried out for the tenants but for the visitors to the city.

When things were just beginning to get comfortable, the wall fell on November 9, 1989. A phase of urban development started, which would simply have development of taken up the Greater Berlin of the pre-war area, if it had not been for the need to deal with the ever-visible consequences of war and division and the new conditions of a globalized world. After an unusually passionate debate, a narrow majority of the Bundestag decided to move from Bonn to Berlin. On October 30 the parliamentary advisory committee chose the building of the former Reichstag as the seat of the parliament. In 1996 the Bundesrat vote taking up residence in Berlin as well. As the capital, Berlin all the more calls for dignified architecture that

Potsdamer
Platz 1996

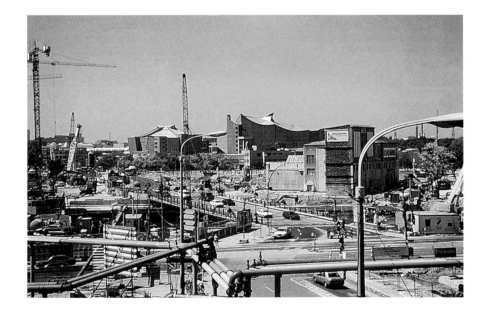

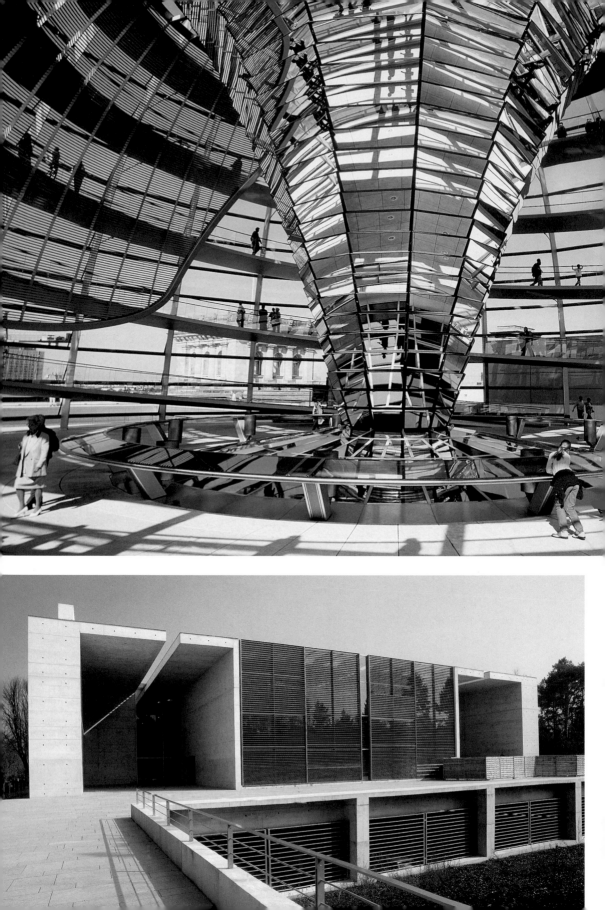

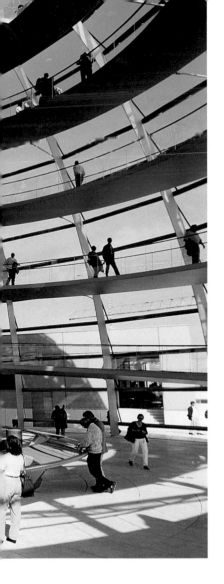

Above:
Reichstags
Building, dome
(see p. 14-17)

Left:
Crematorium
by Axel Schultes,
Baumschulweg,
1996-98
(see p. 156,
157)

on the following areas: The government buildings settled in the Spreebogen and in Bezirk Mitte in the area where Unter den Linden and Friedrichstrasse cross. The Ministry of the Interior moved into a new building in Moabit. In order to save costs and to prevent the city from becoming stifled by a self-contained government district, existing buildings were changed in their function, if possible. The Baroque Schloss Bellevue (Palace Bellevue) remained the seat of the president of the Federal Republic of Germany and was expanded by an administration building fitting in discreetly with the scenery of Tiergarten. Most embassies took up residence in southern Tiergarten between Klingelhöferdreieck and Kulturforum.

The modernising reconstruction of Bezirk Mitte in the area of Unter den Linden and Friedrichstrasse started by the GDR was continued according to the principles of "critical reconstruction". Pariser Platz in front of the Brandenburg Gate, the city's emblem and a symbol of reunification, is given back its former shape.

Potsdamer Platz, before the war Europe's most busy square, was now a flat border area after being demolished by bombs in World War II. It was enclosed on the west by high-rise buildings which formed a kind of gateway leading up to the apparently evolved block margin development of the debis-area or Sony Center. Unlike US sky-scraper cities, high-rise buildings here are meant to accentuate the cityscape, similar to the two residential towers at the Frankfurt Gate (1957-60) or the church steeples on Gendarmenmarkt. The intended mixed use of living, working and shopping areas corresponds to this. An answer to the new buildings drawn up in the eastern Friedrichstrasse and around Potsdamer Platz is provided in the west around Bahnhof Zoo, on Kurfürstendamm and on Tauentzienstrasse by a number of office and business premises, which, like the Kanzlereck by Helmut Jahn, still appear strange within the familiar juxta-

meets to the highest expectations. The enormous volume of building and the diversity of constructions make Berlin a mecca for architects, providing them with the opportunity of taking part in the creation of a European metropolis on the threshold of the 21st century. Contrary to her sisters on the Seine, the Thames or the Tiber, whose appearance can hardly be changed considerably any further, the city on the Spree still seems to permit architectural experiments in spite of the restrictions imposed by the protection of historical monuments.

Urban developments first concentrated

position of buildings dating from the Gründerzeit (the years of rapid industrial expansion after 1871) and the 1950s. Apart from the central areas mentioned bordering on Tiergarten, new buildings and accomodations are popping up virtually all over the city. Reference should be made at this point to the Wasserstädte (Water Towns) at Spandauer See (Spandau Lake) or the Rummelsburger Bucht (Rummelsburg Cove), which are meant to prevent the overdevelopment of the periphery and to make it possible for families with children in particular to live in natural surroundings.

Enormous building schemes are to take the rebuilding of the city further and to a preliminary end within this and the following decade. Work on buildings that are vital for the infrastrucure like the Lehrter Bahnof (Lehrter Station) is in progress. The reconstruction of Potsdamer Platz is approaching its completion. In the foreseeable future gigantic excavations are going to gape around Leipziger Platz and Alexanderplatz. The most important project, however, probably constitutes the reconstruction of the historical buildings on the Museumsinsel according to the principles of the preservation of historical monuments, and their common access via a modern entrance building by the British architect David Chipperfield.

Today, there is probably no other city in which so many different architectural styles are being tried out like in Berlin thus contributing to the diversity of the metropolis. Postmodern eclecticism has played its part in this process. The tone is set by neoclassical and deconstructionist tendencies. Also of general interest are technically innovative solutions particularly in the field of ecological construction. The principle of "critical reconstruction" represented by Josef Paul Kleihues, which has largely been adopted by town planning, has to a considerable degree contributed to a kind of local style, which is, however, some-

what submerged within the concert of other styles. The demanded block margin development, which forbids individual buildings to stand out, favours among other things the striking corner buildings most typical of Berlin, which are either rounded or equipped with a tower, and contain often the entrance. The Mosse House by Erich Mendelssohn (1921-23) has set an example for this. The achievements of the best architects cannot simply be subsumed to one style, since they have been taking up different traditions as well as creating new styles. Architects like Axel Schultes, Daniel Libeskind or Helmut Jahn have their personal styles, which can only be appreciated if one looks at the artist's entire work, and not only at the Berlin buildings. However, the architects' differing attitudes often produce similar results.

Most striking about the new architecture in Berlin are its mimetic qualities, which find their expression not least in the inflation of the affectionate, not always ironic nicknames used for the buildings, such as "lemon", "armadillo", "amoeba", "snake", etc.

In the sense of a "speaking" architecure, many a facade explains the function of the building, as demonstrated by the Zentrale der Berliner Wasserbetriebe (center of the Berlin water supply) and by the Peek & Cloppenburg department store. The existence of models like the hat facto-

Jakob-Kaiser Haus (see p. 28)

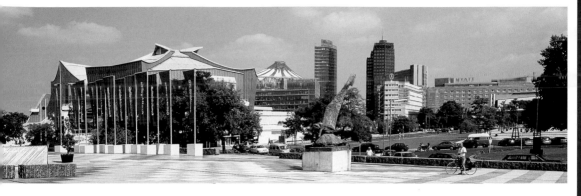

View from Kultur-
forum to the
Potsdamer Platz

ry in Luckenwalde by Erich Mendelssohn or, a more recent example, the Bibliothèque Nationale by Dominique Perrault doesn't alter the fact that architecture today tends to take on pictorial features. In Berlin this tendency has culminated in the politically symbolic forms of the Reichstagkuppel (dome of the Reichstags building), which elevates the people above parliament, and the "Band des Bundes", which visibly brings East and West together again. Apart from the pictorial, an affinity with sculpture can also be observed. Plasticity and sculptural qualities are features of buildings which could hardly be more dissimilar. It was possible to compare the "flash form" of the Jüdische Museum (Jewish Museum) by Libeskind with the memorial to the Märzgefallenen (the soldiers who died in March) by Walter Gropius (1920), and from a distance the futuristic dome-shaped construction over the Sony Center reminds one of the monument design for the IIIrd Internationale by Wladimir Tatlin (1919-20). In his large-scale sculptural projects Axel Schultes proves himself a modern Michelangelo, and Frank O. Gehry conjures up architectural constructions of an enormously plastic effect with the help of special computer programs.

In general, architecture tends to be open towards other arts, towards literature and philosophy, and to become modest with regard to its achievements. French architects like Jean Nouvel with his architecture of glass and light, which he was allowed to put into effect in a department store of all buildings, and Dominique Perrault, whose sports buildings, which had been planned for the failed olympic project in Berlin, provide examples of an invisible architecture, are examples of this. The "high-tech architecture" by the British architects Foster, Grimshaw and Wilford, which have to the Centre Pompidou as a model, exposes the buildings' internal structures and makes them appear like intelligent machines populated by ant-like human beings.

What makes architecture in Berlin stand out is not least its constant effort to reconcile history with the present. Here, a new building is only considered successful if it shows consideration for older buildings, which sometimes have been given up for the sake of the new one, and if it doesn't destroy their "aura". For some architects like Kleihues this consideration for the specific situation of a place also requires an intimate historical knowledge, for example about the former residents of a district. The Libeskind Building is a case in point, as it proves that it is possible to create architecture for the "genius loci" with new buildings, which, although they appear like alien elements in their surrounding areas, seem to be derived from a topography of the city revealing many an exemplary individual fate with the help of imaginary references.

(Translated by Stefanie Woyth-Gutberlet)

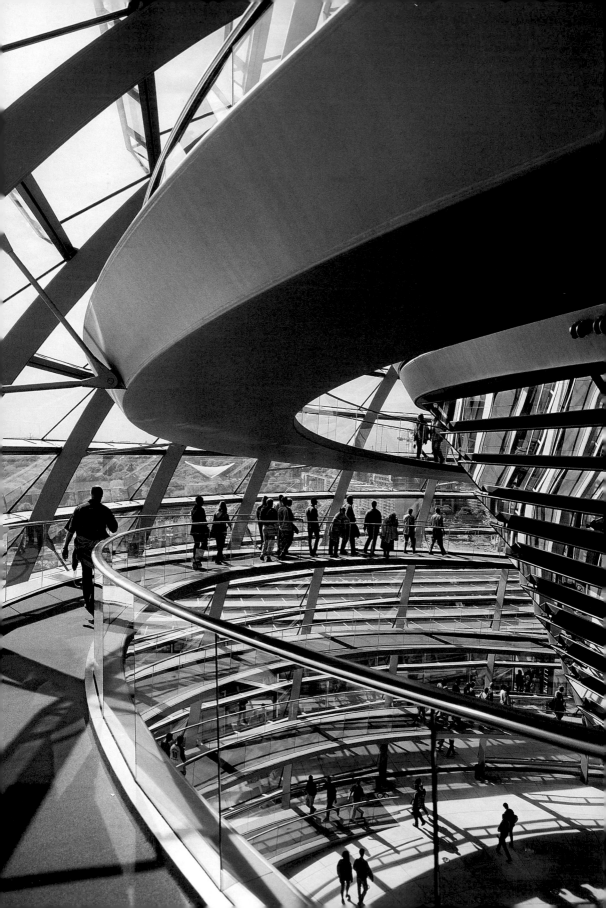

Reichstagsgebäude (Reichstags Building)
Deutscher Bundestag (German Bundestag)
(Scheidemannstrasse/Ebertstrasse)
architects: alterations: Sir Norman Foster &
Partners, London/Berlin
alteration 1994-99

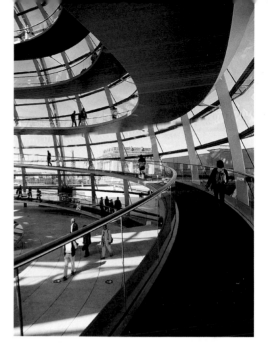

The splendid neo-Baroque building was erected
from 1884-94 according to the designs by Paul
Wallot. The building, which is 137 meters long
and 97 meters wide, had a gigantic glass dome
and an imperial crown on the top. From 1894-
1933 it was the meeting place of the parliaments
of the Empire and the Weimarer Republic. The
remains of the dome which were strongly dama-
ged during the Second World War were blown up
in 1954. From 1961 on the building was remodelled
by Paul Baumgarten as the Berlin branch of the
Bundestag (sine 1972) and as a convention cen-
ter and a show room. On October 4, 1990 the
first meeting of the reunified German Bundestag
took place here. After passing the resolution to
transfer the government from Bonn to Berlin the
Bundestag decided to use the Reichstag as the
German parliament on October 29, 1991. In 1993
the British architect Sir Norman Foster was
asked to transform the building into the new
meeting place of the German Bundestag. Foster
had the post-war construction removed in order
to regain the remaining substance of the original
neo-Baroque building. After a heated debate in
1995 the Bundestag decided to have a dome
erected again, although in reduced and modern
shape. This was contrary to Foster's orginal plan
for a baldachin-like roof. The walk-in glass dome
is already a major sight in the city and is accessi-
ble to the public. It is directly above the assem-
bly hall. The delightful way in which mirrors play
with the light is quite fascinating.

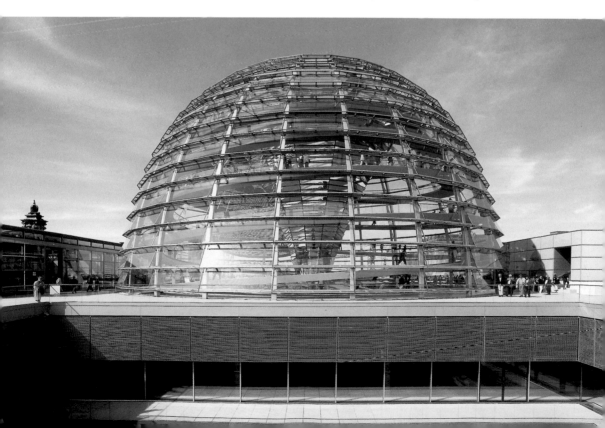

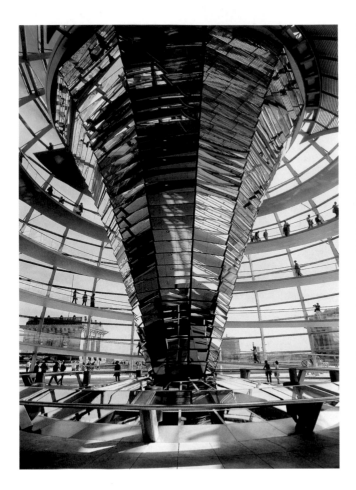

Sir Norman Foster

Sir Foster became well-known in Germany through the alteration of the Reichstag Building (1994-99) even though he was already a famous architect who had received numerous awards e.g. the Royal Gold Medal for Architecture (1982) and got ennobled in 1990.

This innovative and creative artist of high-tech architecture who is well-known for his intelligent linking of function and technology was born in Manchester in 1935 and studied at Manchester University and Yale University in New Haven. He has offices in London, Hong Kong, Tokyo, Frankfurt/ Main and in Berlin with serveral hundred employees.

His masterpieces are elegant and impressive: the 180 meter tall Hong Kong and Shanghai Bank in Hong Kong (1986) – the most expensive building of the 20th century – and the 258 meter high Commerzbank Headquarters in Frankfurt/ Main (1997) – the highest building in Europe. Together with the new airport in Hong Kong and some more skyscraper projects in Tokyo the architect will carry out some more superlative buildings.

The Reichstag dome is also an example of his creativity: Harmonical transparency of the construction is achieved by using cutting-edge technology and materials with perfect precision.

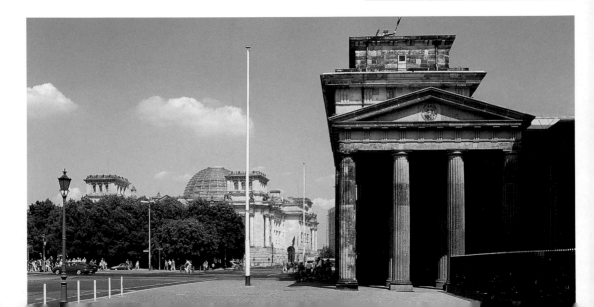

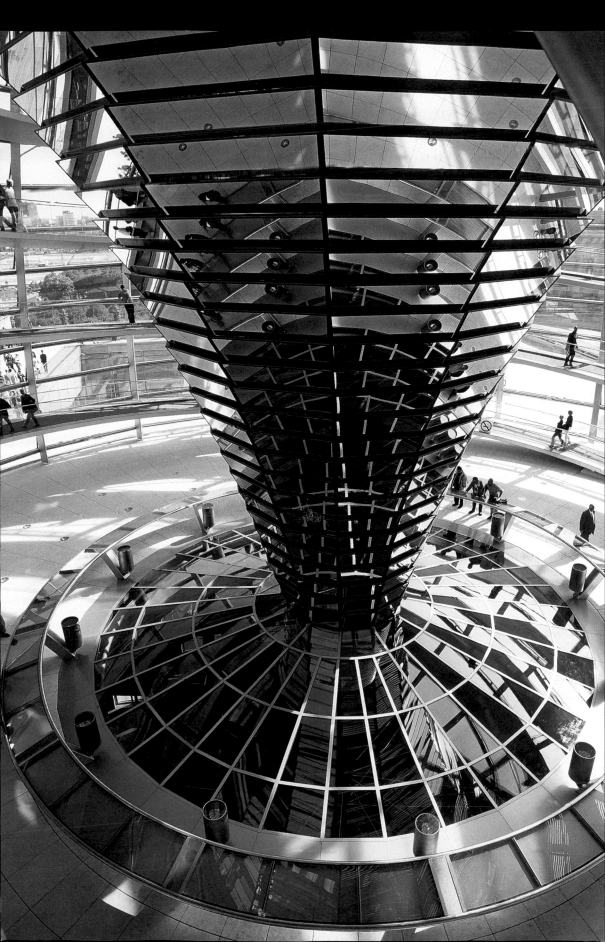

"Band des Bundes"
(The Ribbon of Government Buildings)

The German government's construction project north of the Reichstag is called Band des Bundes. It stretches from the Kanzlerpark in the west, which was laid out according to plans by Cornelia Müller and Jan Wehberg on the opposite side of the Spree and is accessible by crossing a bridge, past the monumental Federal Chancellery and up to the Paul-Löbe and Marie-Elisabeth-Lüders houses. It therefore symbolically links East and West Berlin which were separated between 1961 and 1989. Another major building project in this area is the Lehrter Train Station, which will be completed by 2004.

Map
"Band des Bundes"

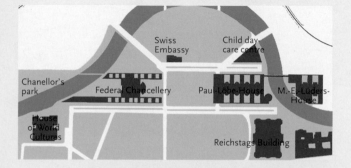

Federal Chancellery

(Willy-Brandt-Strasse)
Architects: Axel Schultes, Charlotte Frank, Berlin
1997-2001

The monumental Federal Chancellery is part of the "ribbon of government buildings" and is closely associated with the Paul-Löbe- and Marie-Elisabeth-Lüders Houses as well as to the Reichstag Building. The central block is 40 meters high and is flanked by five storey (22 meters) high administrative buildings. The northern and southern wings form two courts of honour in the west (to the Paul-Löbe House) and east (to the river Spree). To the west on the other side of the river Spree follows the chancellor's park which was designed by Cornelia Müller and Jan Wehberg.

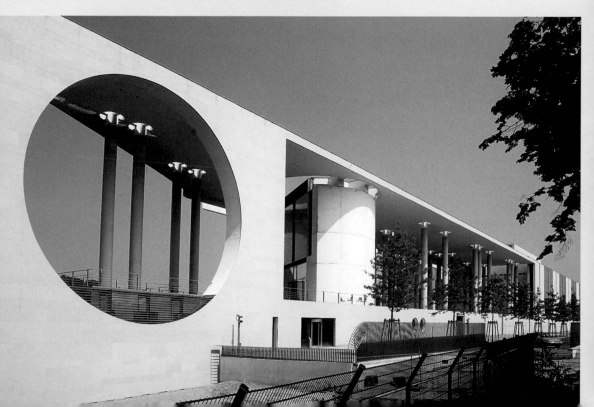

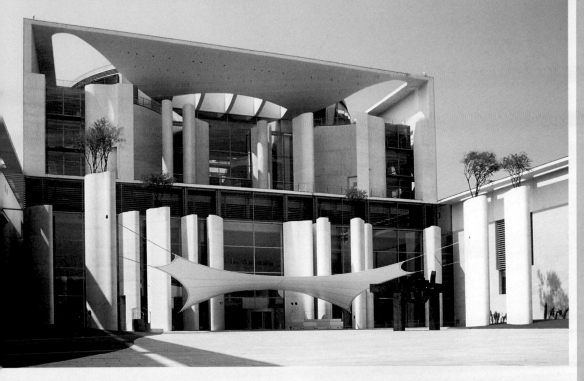

Axel Schultes

The architect of the Federal Chancellery and the winner of the urban planning competition "Spreebogen" (1993) became famous for his impressive new museum buildings, Kunsthalle Schirn in Frankfurt (1982 together with other architects) and the Art Museum Bonn (1992). Even though Axel Schulte was already born in 1943 he designed only a few other buildings. A major example in Berlin is the Crematorium in Berlin-Treptow (compare p. 156, 157).

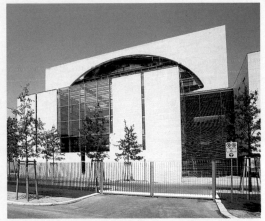

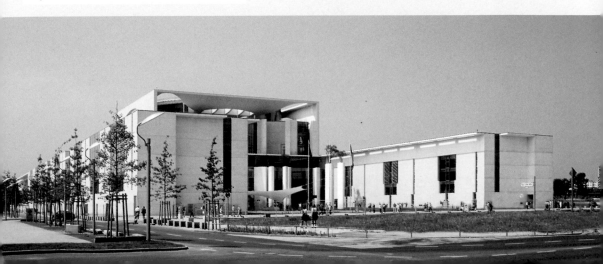

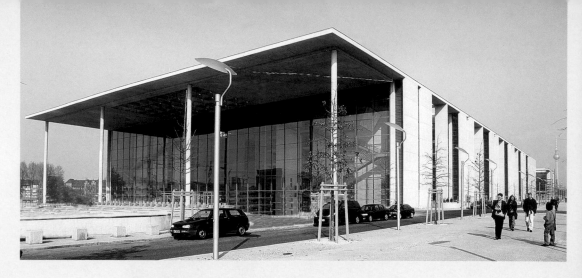

Paul-Löbe-Haus/Parliament building
(Paul-Löbe-Allee)
Architect: Stephan Braunfels, München/
Berlin
1997-2002

The building to the west oft the river Spree
is part of the "government ribbon". It is
connected to the Chancellery and, together
with the Marie-Elisabeth-Lüders House on
the opposite side of the Spree, it forms a
formal und functional whole. The Paul-Lö-
be-House was designed by Braunfels. It
contains more than 900 offices for the
parliamentary deputies. The building is
200 meters long, 100 meters wide and
22 meters high. It has the form of a double
comb with eight outer courtyards. The
main entrance in the west is situated un-
der a large imposing porch with four fili-
gree columns. A large glass-roofed hall,
glass-enclosed lifts and transparent stair-
cases are in the middle of the block.
The building is named after the last parlia-
mentary president, until 1933, Paul Löbe.

Marie-Elisabeth-Lüders-Haus
(Schiffbauerdamm)
Architect: Stephan Braunfels, Munich/
Berlin
1998-2002

The Marie-Elisabeth-Lüders-House is situa-
ted on the eastern bank of the River Spree.
It creates a functional and formal unity with
the Paul Löbe House on the western band.
The two buildings are connected via a pu-
blic footbridge. The circled housing next to
the river is used as the parliamentary
library. Besides the building houses are the
parliamentary archives and other scientific
and academic services and offices .

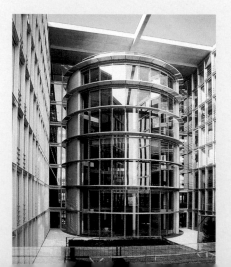

Stephan Braunfels was born in 1950 in
Überlingen at the Lake Constance and
grew up in Aachen. He studied from
1970 till 1975 in Munich. The new star
among the German architects was not
very high in demand during the 70s and
80s.
In 1992 and 1994 he won two important
competitions, for the Pinakothek of mo-
dern art in Munich and the international
competition of the buildings for the
members of parliament (Paul-Löbe- and
Marie-Elisabeth-Lüders-House) in Berlin.
Braunfels comes from a family of artists.
His great-grandfather was the famous
sculpturer Adolph von Hildebrand, his
grandfather was the componist Walter
Braunfels, his father was Wolfgang
Braunfels a famous historian of art.

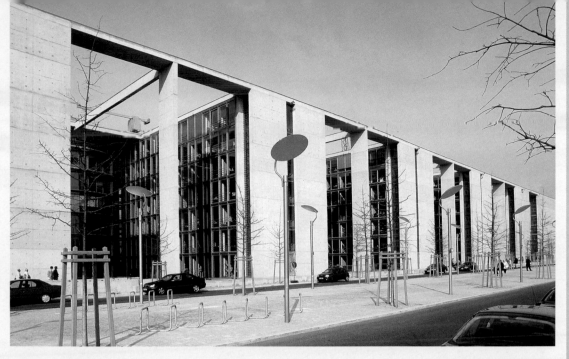

Paul-Löbe-Haus

Swiss Embassy
(Otto-von-Bismarck-Allee 4)
Architects: Diener & Diener, Basel
1999-2001

The architects Diener & Diener designed the extension building following the proportions of the old building which was built in 1870 by Hitzig and extended in 1910 by Paul Baumgarten.

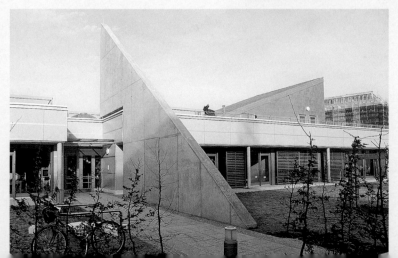

Child daycare centre
(Otto-von-Bismarck-Allee 2)
Architects: Gustav Peichl & Partner, Wien
1998-99

The blue building located to the Paul-Löbe-House was designed for 176 children of the members of the German parliament.

Federal Ministry of the Interior
(Alt-Moabit 98-101)
Architect: Kühn Bergander Bley, Berlin
1992-94

The imposing building of the Ministry of the Interior is prominently placed within the city along the Spree river. The 120 meters long U-shaped office building has 13-storey towers at its two ends. The 42 meter high mirror glass cylindrical towers dominate the silhouette which characterises the visual appearance of the bank of the river Spree. The block is faced with reddish brown granite and has horizontally placed windows that are almost flush with the wall. The new building was already finished in 1996 and leased for 30 years by the ministry. Its 900 workplaces account for nearly 3/5 of the office space in the building.

The building is framed by the Bolle dairy and Focus Teleport in the west and the new building of the Moabit District Court in the east.

Above:
Bolle Dairy/
Hotel Sorat (left)
and Federal
Ministry of the
Interior (right)

Old Bolle Dairy/Hotel Sorat
(Alt Moabit 98-104)
Architect: Wolf-Rüdiger Borchardt, Berlin
1993-95

The Old Bolle Dairy is a protected archi-
tectural monument from 1890 which
was converted into a restaurant, hotel
and several shops. The new building
next to the river Spree is mainly of glass-
steel construction.

below:
Focus Teleport

Focus Teleport
(Alt-Moabit) 91-96
architects: Ganz & Rolfes, Berlin
1988-92

The old buildings and grain mills of the
former Kampffmeyer company were
almost totally demolished after the
facility was closed down at the end of
the 1980s. In 1988 a "new enterprise-
founders' center" with new buildings
for technology companies was erected
on the site. The basic structure of the
architecture is based on the square.
It appears systematically in the facade
(particularly windows) as well as on
the proportions of the blocks. The steel
elements are painted in blue and are
combined with terracotta elements
and square windows in square formats.

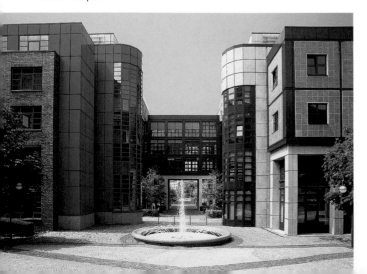

The Federal President's Office

(Spreeweg 1)
architects: Martin Gruber + Helmut
Kleine-Kraneburg, Frankfurt a. M./Berlin
1996-98

One of the most remarkable new buildings in Berlin is the Federal President's Office with its 150 work places. It is located next to the palace Bellevue. The four-storey building is a well-proportioned and uniform block on an elliptical ground plan. The 82 meter long and 41 meter wide ellipse has a polished black granite facade with windows which fit flush into the facade. Inside the inner elliptical courtyard which is open to daylight is a central block containing a library and other rooms which can be reached by bridges. Solar cells on top of the roof provide about 50 % of the energy.

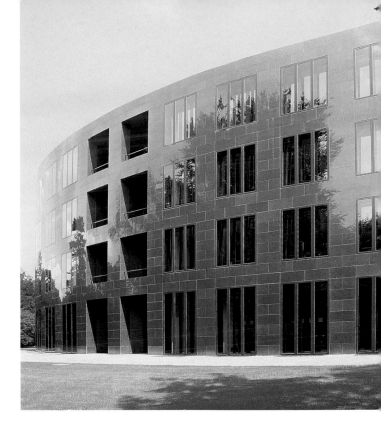

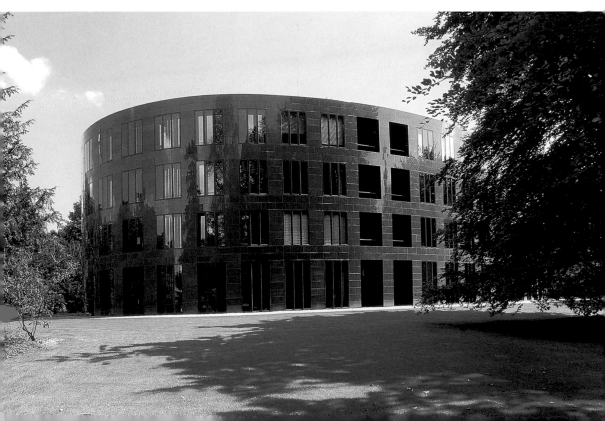

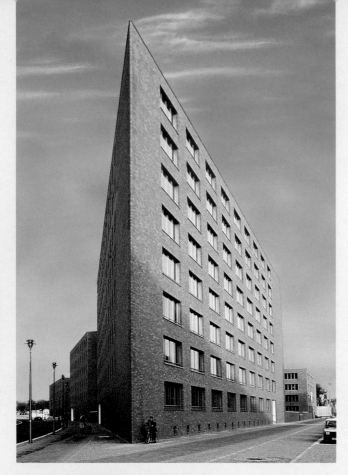

Residential area for government employees
(Paulstrasse)
architects: Georg Bumiller, Berlin ("snake");
Jörg Pampe, Berlin (head building);
Urs Müller, Thomas Rhode & Jörg Wandert
(atrium houses), 1997-99

The biggest housing project of the German government in the city centre of Berlin is this residential building for government employees. The original main building of 300 meters length was built according to plans by Bumillers. Its ground plan has the shape of a wavy line made by a snake. In addition to this complex with 718 apartments, the site contains four apartment blocks by Müller, Rhode & Wandert and, in the western part, a brick building from 1934. Further buildings include a new sports hall, a power plant and a children's day centre designed by GKK & Parners.

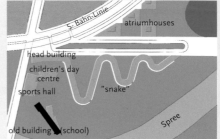

Top: Atrium Houses

Left: head building of the "snake" by Jörg Pampe with four shopping and office storeys and four apartment storeys above.

Right: Close-up of the main building and children's day centre

Below right and left: sports hall

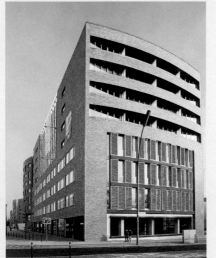

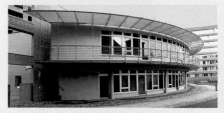

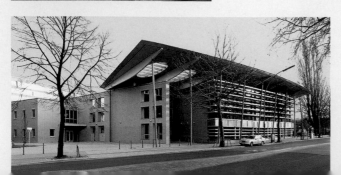

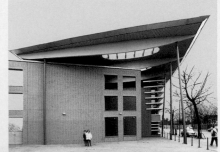

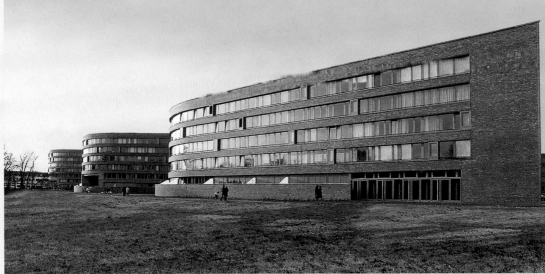

The "snake", the winding block, with 440 apartments (about half of them are one bedroom apartments) is, if stretched, more than half of a kilometer long. The building is only 300 meters long because of its snakelike shape. Due to cunning details the building does not appear monumental.

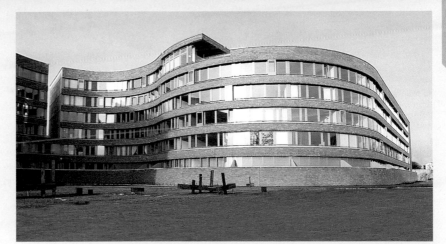

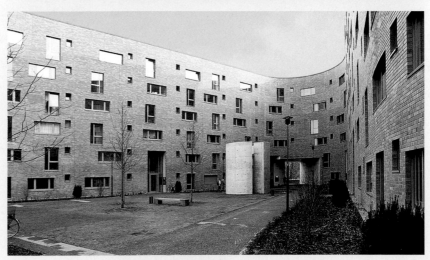

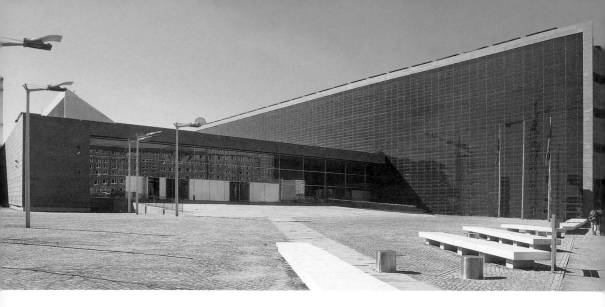

Federal Press
Office

Federal Press Office
Dorotheenstrasse/Reichstagufer/Neu-
städtische Kirchstrasse
architects: KSP Engel und Zimmermann,
Berlin
1996-2000

The Federal Press Office is located in
several historic, GDR-era, and new buil-
dings. Next to the Spree and the train sta-
tion Friedrichstrasse there is a 120 meter
long new building with a filigree and
transparent outer glass surface.

Jakob-Kaiser
Haus

Jakob-Kaiser Haus
(Dorotheenstrasse/Wilhelmstrasse/Ebert
strasse)
architects: Busmann & Haberer, Cologne;
De Architekten Cie, Amsterdam; gmp
(von Gerkan, Marg & Partner), Hamburg;
Thomas van den Valentyn, Cologne
(Planungsgesellschaft Dorotheenblöcke
PGD, Berlin)
1996-2002

The Jakob-Kaiser House is located right
next to the Reichstag Building and con-
sists of two big blocks with eight open
inner courtyards to provide light. The to-
tal of 2.000 rooms with 45.000 square
meters of floor space contain offices for
395 members of parliament, parliamen-
tary groups and employees of the parlia-
ment, meeting rooms for committees
and a press center. Five architects offices
developed a joined concept with indivi-
dual buildings. The architectural structure
follows the principles of "critical recon-
struction" which means that the land has
been split up in two separate land parcels
on which eight individual interlinked buil-
dings have been constructed. The buil-
dings which are protected monuments,
i.e. Parlamentarische Gesellschaft (Ebert-
strasse 30/31) by Paul Wallot (1897-1904)
facing the Reichstag and the buildings on
Dorotheenstrasse 105 (1853-57/1910-11) as
well as the former "Kammer der Technik"
(1912-14) on Eberstrasse are being renova-
ted, alterated and integrated into the
ensemble.

Hospital Charité: Max-Planck-Institut für Infektionsbiologie (ill. right)

Schumannstrasse 20-21
architects: H. Deubze/J. König, Berlin
1997-99

The building with the monumental entrance hall is very opaque. The brick facades form a bridge to the older architecture of the hospital.

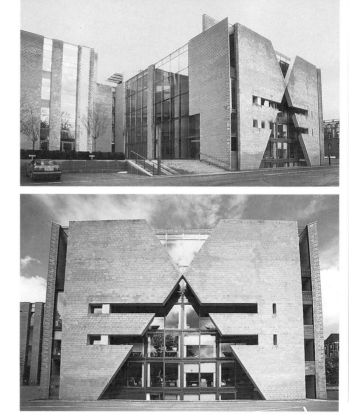

Federal Ministry of Economic Affairs and Technology

(Invalidenstrasse/Scharnhorststrasse 36/37)
architects: Thomas Baumann & Dieter Schnittger, Berlin
1997-99

The ministry moved into the neo-Baroque building of the former Kaiser-Wilhelm Academy (1905-10 by Cremer & Wolffenstein) and into the invalids' building (1746-48) by Isaak Jacob Petri. The new three-wing building (1997-99) for 400 workplaces is on the Berlin Spandau shipping canal opposite the Hamburger Train Station.

Reinhardtstrasse Residential area (illustration below)

Reinhardtstrasse 29 and 31
architects: Bellmann & Böhm with Krüger, Schuberth, Vandreike, Berlin, 1996-98

The residential area is located beside the rest of a gate which was de-signed by Carl Hampel 1828 according to the ideas of Carl Friedrich Schinkel. The cubic building behind the gate is particularly charming. With its big windows the building has a filigree and transparent style.

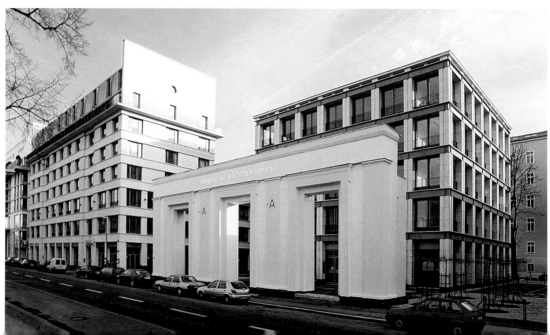

Federal Ministry of Transport, Construction and Residential Development

(Invalidenstrasse 44)
Architect: Extension building: Max Dudler, Berlin
1997-99

The Federal Ministry is located in the building of the former State Geological Institute (built from 1875 on by August Tiede) and in a new building by Max Dudler covered with stones. The six storey, uniformly designed office building with grid-type perforated facade and greenish grey natural stone has a cubic form and a square ground plan with an inner courtyard. In its proportions the new building is similar to the older ones. The architect Max Dudler was born in Switzerland in 1949 and does not use a lot of ornaments. His architecture is totally functional with plain structures as you can see by his designs on Behrenstrasse, at Gendarmenmarkt and the new school in Hohenschönhausen.

Above: Office Building (Reinhardtstrasse 39/Luisenstrasse 42)
Below: Federal Ministry of Transport, Construction and Residential Development

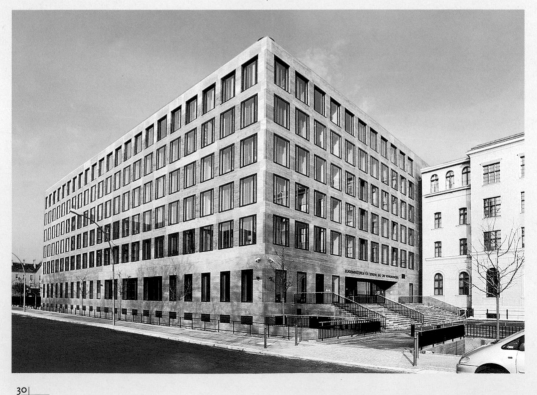

Federal Press Conference

(Schiffbauerdamm 35-39/Reinhardtstrasse)
architects: Johanne & Gernot Nalbach,
Berlin
1998-2000

The building with its greyish basalt facing is situated next to the River Spree. The only outstanding element is the main room of the Federal Press Conference building in the "piano nobile" with an area of 300 square meters and a height of over five meters. The building houses some 600 journalists from agencies and television companies.

Office Building (illustration left)

(Reinhardtstrasse 39/Luisenstrasse 42)
architects: Eller + Eller, Berlin/Düsseldorf
1994-95

The corner building with its glass facade has a prominent sunshade. The metallic character of the building emphasizes the transparent overhanging roof at the height of the eaves.

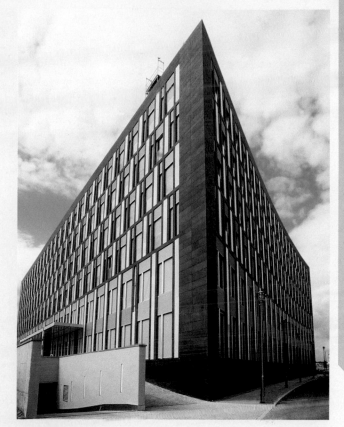

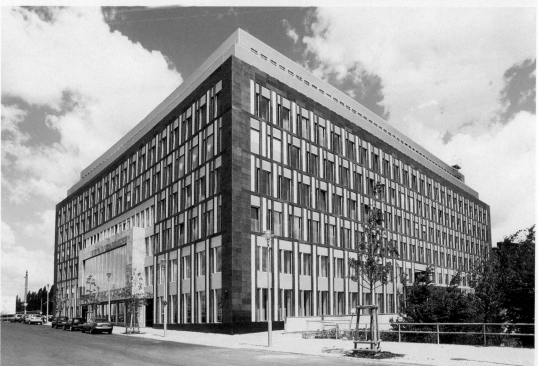

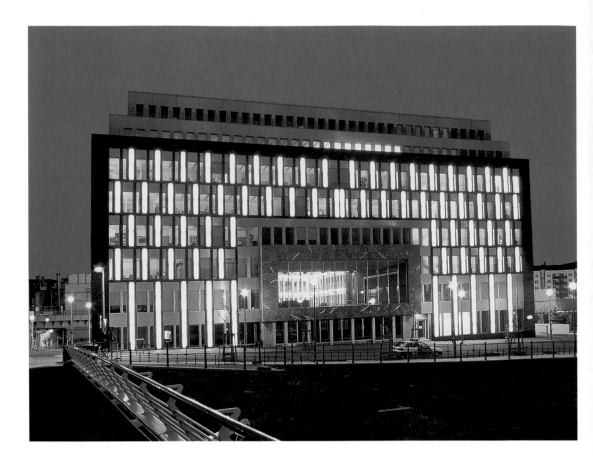

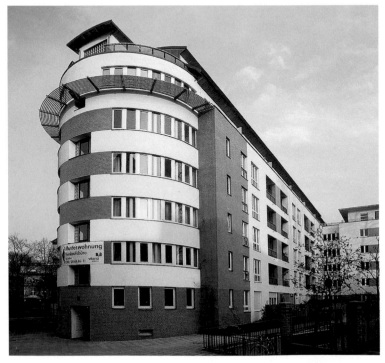

Above: Federal Press Conference (see p. 31)

Luisen Carree
(Robert-Koch-Platz 4/Hannoversche
Strasse 19-22/Philippstrasse 14)
Architect: Stefan Ludes, Berlin
1996-98

The new buildings of the Luisen Carree fit perfectly into the historic surroundings. The characteristic feature of the buildings is the rounded corner. The Luisen Carree includes a big office and shopping center at Robert-Koch-Platz, which extends to Hannoversche Strasse, and a seven storey residential building on Hannoversche Strasse.

**Residential and shopping building
Prismahaus** (illustration below)
(Platz vor dem Neuen Tor 1)
Architect: Josef Paul Kleihues, Berlin
1994-98

The unspectacular sandstone faced building follows the former block structure before the district's destruction during the Second World War. The building has the typical traditional structure: high ground floor, several upper floors and a staggered roof storey which is highlighted by the transparent wing-like roof.

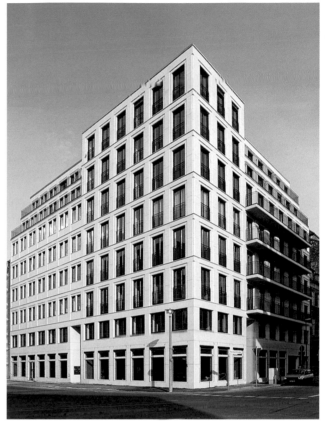

Residential and Shopping Building
(Corner Reinhardtstrasse/Luisenstrasse)
Architect: Walter A. Noebel, Berlin,
1998-99

Above: Residential and Shopping Building at Reinhardtstrasse/Luisenstrasse

Neues Tor (New Gate)
(Platz vor dem Neuen Tor)
Architect: Josef Paul Kleihues, Berlin
1993

The New Gate is one of the access points to the old center of Berlin. The two cubic buildings use modern architectural elements to recreate the gate buildings designed by Schinkel 1830-40 which were torn down after the Second World War.

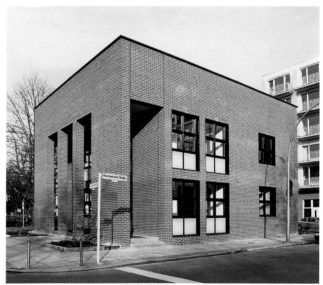

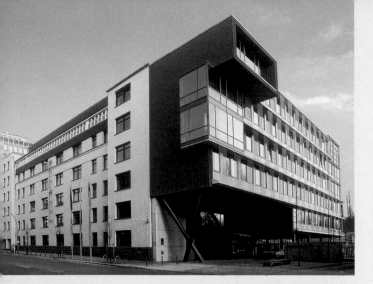

Federal Ministry for Education and Science
(Hannoversche Strasse 30)
architects: Anbau: Jochem Jourdan & Müller, Frankfurt/Main
1999-2000

The building of the 19th century was changed in 1949 by Hans Scharoun into the "Institute for Building". From 1971 till 1990 it was the seat of the "Permanent Delegation of the Federal Republic of Germany in the German Democratic Republic". Like the former Info-Box at Postsdamer Platz the new extended building differs in its color and by having overhanging storeys from the old building while keeping the original eaves height.

Federal Ministry
for Education and
Science

Catholic Academy and German Bishops' Conference Building
(Hannoversche Strasse 5/Chausseestrasse 128-129)
architects: Höger Hare Architekten, Berlin; RKW Rhode, Kellermann Wawrowsky & Partner, Berlin
1998-2000

The building next to the street possesses horizontal window openings, some of which run ribbon-like around the corner. Behind the yard there is a yellow administration building and guest house with a new chapel.

The ARD studio in the capital
(Wilhelmstrasse 67a/Reichstagufer 7/8)
architects: Laurids Ortner & Manfred Ortner, Vienna/Berlin
1996-98

Since 1999 the office building on Reichstagufer is the new ARD studio of the capital for radio and television broadcasting. The long cubic building follows the loop of the southern bank of the river Spree. The window openings are staggered behind the facing of red stone. The red color harks back to the historical brick buildings of the 19th century.

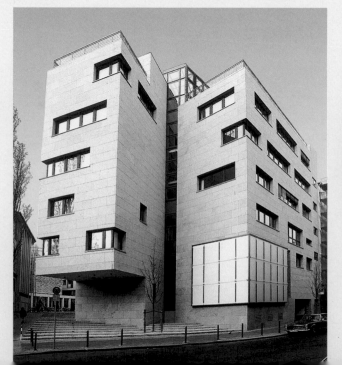

Catholic Academy with guest house and chapel (above) and German Bishops' Conference Building next on the site towards the street (left)

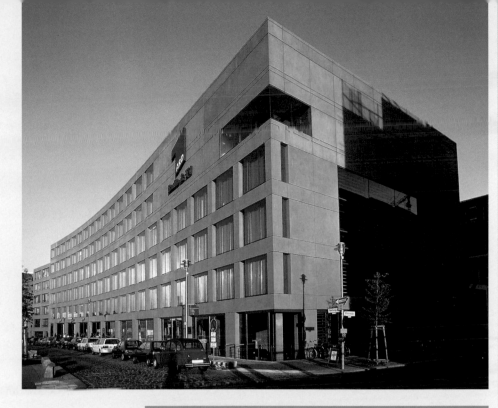

ARD studio in the capital

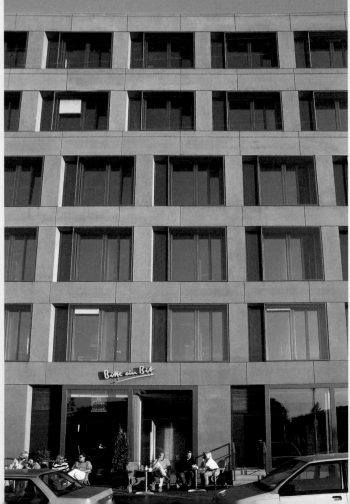

Pariser Platz

The plaza, which was laid out from 1732-34 received its name after the taking of Paris by the anti-Napoleonic alliance in 1814. The Quadriga, the chariot on top of the Brandenburg gate, had been taken to Paris on Napoleon`s orders after Prussia`s defeat in 1806. In 1814 it returned to Berlin in a triumphal procession.

The Brandenburg Gate is the trademark of Berlin. Since it was a symbol of the partitioned city from 1961 until 1989. Since the fall of th Wall on November 9, 1989, the Brandenburg Gate has been the symbol of the reunified Germany. In addition, it is a major art monument, as it is one of the earliest and most important Neoclassical gates.

The current gate replaced an old town gate from 1735. It was designed by Carl Gotthard Langhans in 1788 and is based on the propylaeum of the Acropolis in Athens. The gate was constructed from 1789-91 and was completed in 1793 by the addition of J. G. Shadows Quadriga – a 6-meter tall sculpture of the goddess of victory riding in a chariot. After the demolition of the old customs barrier, J. H. Strack rearranged the plaza. After being damaged during the Second World War it was reconstructed in 1956-57.

The other buildings at Pariser Platz were torn down due to damage received during the Second World War. The Brandenburg Gate became the border between East and West Berlin and Pariser Platz was part of the GDR border area ("Berliner Mauer" – Berlin Wall which was errected in 1961 and was torn down after its opening in 1989).

The first attempts to rebuild Pariser Platz were in 1990. In 1993 the senat of Berlin decided to restore Pariser Platz according to its old proportions. It was planned to restore the old small plot structure and the function of the buildings existing before the Second World War, the Hotel Adlon, the Academy of the Arts, the United States Embassy and the French Embassy were established on the same plots. They had prior to the Second World War. The design principles of 1993 and 1996 stipulated that the facades have to be devided in three horizontal parts (raised ground floor, several full upper floors and staggered roof storey) consisting of a light colored stone or rendered wall and that the window openings should not exceed 49 % of the facade. The height of the buildings had to follow the old forms before 1945. Glass facades were to be avoided in favour of grid-type perforated facades. The only exception was the extraordinary design by Günter Behnisch for the glass facades of the Academy of the Arts.

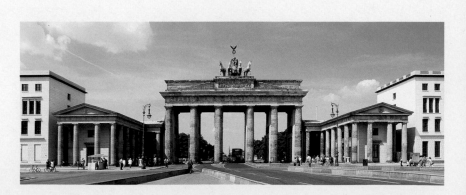

Hotel Adlon

(Unter den Linden 75-77)
architects: Patzschke, Klotz & Partner,
Berlin
1995-97

The old Hotel Adlon from 1907 was one of Berlin`s legendary luxury hotels. It was damaged during the Second World War and afterwards blown up. The present historic-modern building (1995 - 97) by Patzschke, Klotz & Partner was the first new building on Pariser Platz. The new Hotel Adlon takes up the old tradition. The architects therefore used post-modern patchwork design with traditional, historical architectural ornamentation. The facade consists of sandstone. Consoles, balustrades, dormer roof windows and iron railings provide the facades with structure and rhythm. The architecture therefore appears traditional, elegant and luxurious.
The arcade-like window openings on the ground floor and rustica design follow the form of the old Hotel Adlon which was half of the size of the new building. The new Hotel Adlon was extended to the Wilhelmstrasse. Further reminiscences of the past are the use of Rackwitzer sandstone from the Bunzlau region in Poland which was also employed for the Berlin Cathedral and the building of the Humboldt University.

The new Hotel Adlon is surely not one of the most exciting new buildings of Berlin but the design principles and the ideas of the owners maybe did not allow a more spectectular architecture.
The architects Rüdiger und Jürgen Patzschke are among the most successful architects of luxury hotel buildings in the world, receiving orders from Arabia, India, Germany, as well as Mallorca. The lavish interior decoration was designed by Julian Reed von Ezra Attia from London and Lars Malmquist from Stockholm.

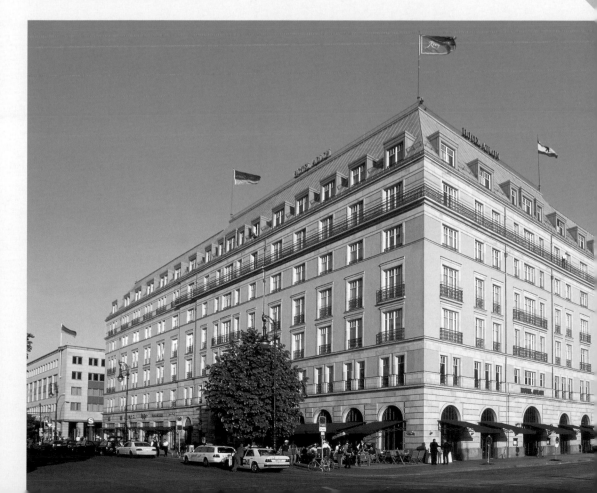

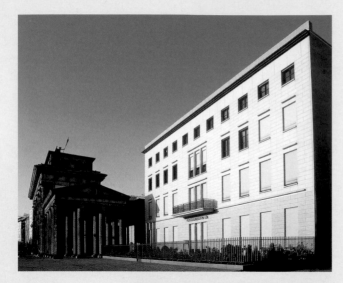

Above:
Sommer Building
Right:
Liebermann Buil-
ding

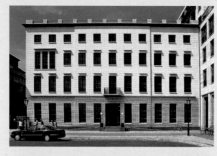

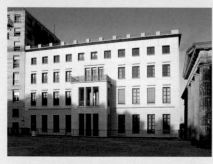

Above: Haus Liebermann from the west

Liebermann Building and Sommer Building

(Sommer Building: Pariser Platz 1
Liebermann Building: Pariser Platz 7)
Architect: Josef Paul Kleihues, Berlin
1996-98

The twin buildings which adjoin the Brandenburg Gate to the north and south have the dimensions, eaves height, sub-divisions and classical forms of the pre-war buildings designed by Friedrich August Stüler (1844 - 46). An essential difference is that the new buildings have four instead of three storeys. The Liebermann Building in the north was the residence and studio of the famous painter Max Liebermann. Here, Kleihues designed two buildings that correspond fully to his ideas of "Kritische Rekonstruktion" and the design principles of the Pariser Platz: by maintaining the dimensions (i.e. eaves height and cubic shape) of the former buildings and using the same construction material.

Palais am Pariser Platz

(Pariser Platz 6a/Ebertstrasse 24)
Architect: Bernhard Winking, Hamburg
(with Martin Froh, Berlin)
1996-98

The classical structure of the residential and shopping building in the north west of Pariser Platz is similar to its predecessor in its outlines and in the use of a tower. The light coloured sandstone facing brick facade is rhythmically structured by window axes. Interesting is the inner courtyard with a sculpture by Stephan Balkenhol.

Below left and
Right:
Palais am Pariser
Platz

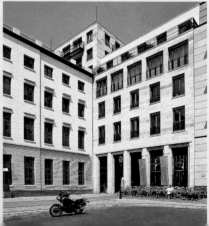

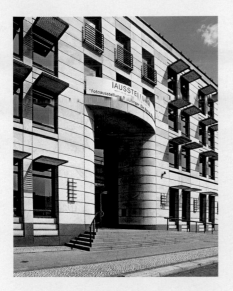

The monumental building is the head-quarters of the Dresdner Bank in Berlin. The symmetrical with its light colored sandstone facing facade is dominated by a portal spanning two storeys and double window openings with sun shade construction. The staggered roof storey is green coloured. Therefore the architecture seems to be classical with a traditional structure: araised ground floor, three full upper storeys and roof storey. Since the building only gets light on the facade, Gerkan, Marg and Partner designed a circular atrium with a diameter of 29 meters. Not only does it provide daylight to the numerous offices, it also is used for various events.

Eugen-Gutmann House of the Dresdner Bank
(Pariser Platz 5a-6)
architects: "gmp" (von Gerkan, Marg & Partner), Hamburg
1996/97

Palais am Pariser Platz (left) und Eugen-Gutmann House

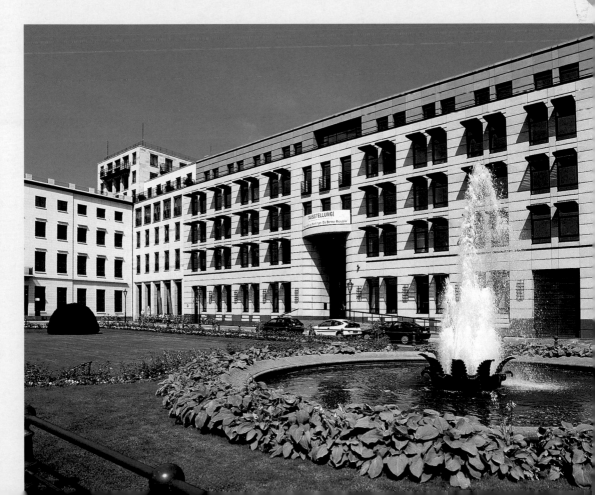

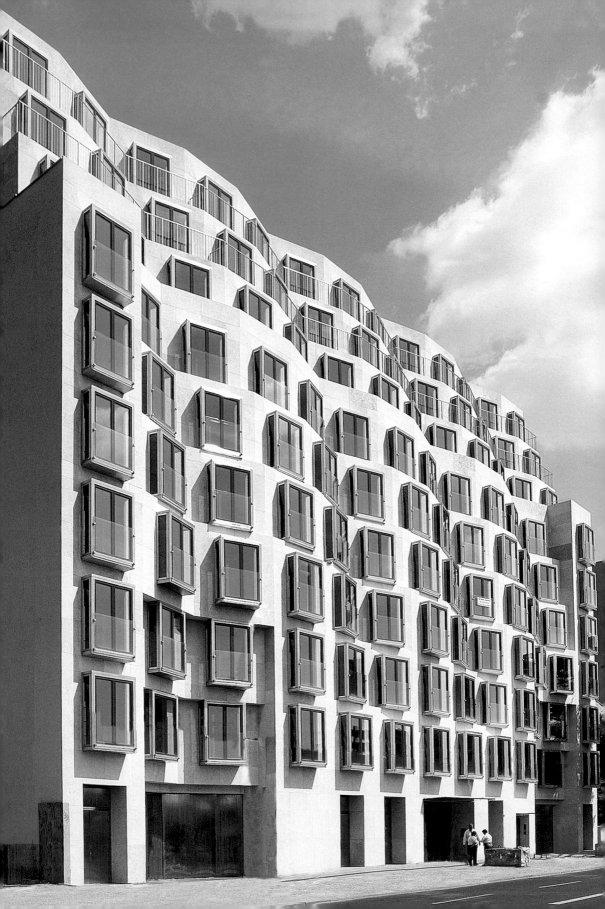

DG-Bank
(Pariser Platz 3)
Architect: Frank O. Gehry, Santa Monica/
USA
1997-2000

One of the most unconventional new buildings is the DG-Bank designed by the Californian star architect Gehry. In keeping with the design of the design principles of the Pariser Platz the architect created a facade with a vertical pillar structure and even window axes. Like the other buildings at Pariser Platz the facade has a staggered roof storey. The second to last storey has sloping windows. Especially impressive is the atrium with a solid asymmetrical glass construction like a spider web and a facing of redish wood. At the southern end of the atrium there is a strange sculptural, metal faced, floating conference room. Remarkable is the facade to the Behrenstrasse with its curving structure, loggias and floor-to-ceiling windows. The top floors are terraced as in many other new buildings and maintain the curving lines at the facade.

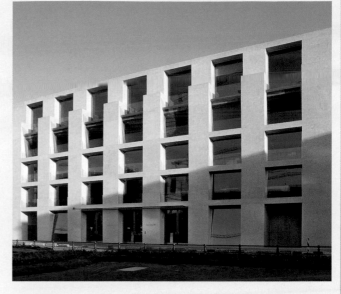

Above: facade to the Pariser Platz
p. 40: facade to the Behrenstrasse
Below: atrium

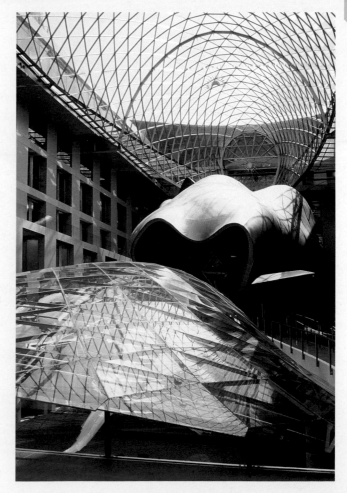

Frank Owen Gehry

Born in 1929 in Toronto (Canada) Gehry became famous for his spectacular designs of museum buildings like the Guggenheim Dependance in Bilbao (1997). The complicated structure of his buildings which could not be created and statically calculated without the aid of computer programs often resembles sculpture more than traditional architecture. In Germany he designed the Vitra Design Museum in Weil a. Rhein (1987-89), the Energy Forum Innovation Building in Bad Oeynhausen (1992-95), the Goldstein Residential Area in Frankfurt/M. (1996) and the parliament in Düsseldorf. After his failed project for the Museumsinsel, the DG-Bank is his first project to be carried out in Berlin.

Academy of the Arts
(Pariser Platz 4)
Architect: Günter Behnisch, Manfred Sabatke, Werner Durth, Stuttgart
2001-02

Although the facade has the alignment and proportions of its predecessor, the Academy of the Arts at Pariser Platz is an exception in that it has a glass front that grants a view into the inside of the building.

United States Embassy
(Pariser Platz 2)
architects: Moore Ruble, Yudell Santa Monica; Gruen Associates, Los Angeles
2001-03

The new building will be erected on the site of the old United States Embassy. It will occupy the largest of the building plots at Pariser Platz. The side facing Tiergarten contains classical and post-modern elements.

French Embassy
(Pariser Platz 5)
architects: Christian de Portzamparc, Paris; Steffen Lehmann, Berlin
2001-02

The building plot expanding from Pariser Platz to Wilhelmstrasse has two inner courtyards. The facade to the Pariser Platz appears monumental because of the raised ground floor, which appears like a high base without big windows, and the upper floors with windows spanning two storeys.

Residential and Shopping Building
(Unter den Linden 80)
architects: Laurids and Manfred Ortner, Wien/Berlin
1999-2000

The strongly structured seven storey building forms the north east end of Pariser Platz. The facades conform to the classical pattern of the opposite building, being a modern variation of the Hotel Adlon.

Unter den Linden 80 (left) and 78 (right)

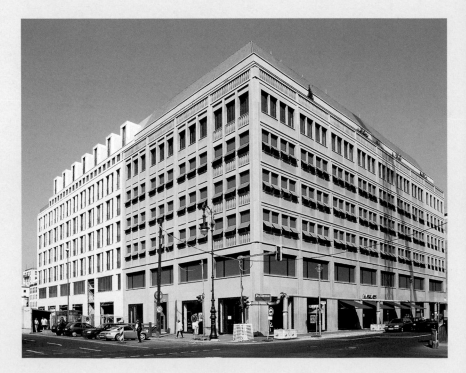

Residential and Commercial Building
(Unter den Linden 78/Wilhelmstrasse)
Hans Kollhoff & Helga Timmermann, Berlin
1999-2000

This unobtrusive building forms the
transition from Pariser Platz to Unter
den Linden. The architect designed a relief-
type sub-division of the grey sandstoned
facade with pilasters and small windows
which are formed into groups of three
openings. The staggered attic storey,
the balustrade and the shape of the roof
emphasize the buildings conservative-
elegant character.

Haus Pietzsch
(Unter den Linden 42)
Architect: Jürgen Sawade, Berlin
1992-95

This seven storey building at the corner
Unter den Linden/Neustädtische Kirch-
strasse was the first building to be
designed according to the principle of
"Kritische Rekonstruktion". The Pietzsch
building is clearly and classically structu-
red. The two transparent ground storeys
form a high base, followed by four storeys
faced with natural stone. A cornice leads
to the attic storeys which form the resi-
dential area. The staggered roof storey as
well as the lateral staircase with a display
wall for an art collection have a glass
facade.

**Office Building for Members of Parlia-
ment**
(Unter den Linden 71)
Architects of the alteration: Gehrmann-
Consult, Wiesbaden
1993-96

Like Unter den Linden 50 the building
Nr. 71 is a completely altered GDR buil-
ding of 1962. In 1993-96 the former GDR
Ministry for Education was remodeled in-
to contemporary structures.

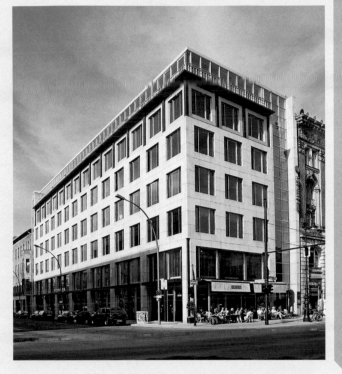

Above:
Haus Pietzsch
Below:
Unter den Linden 71

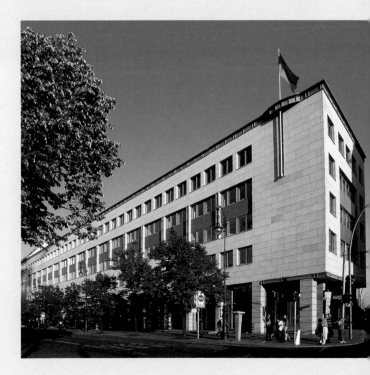

43

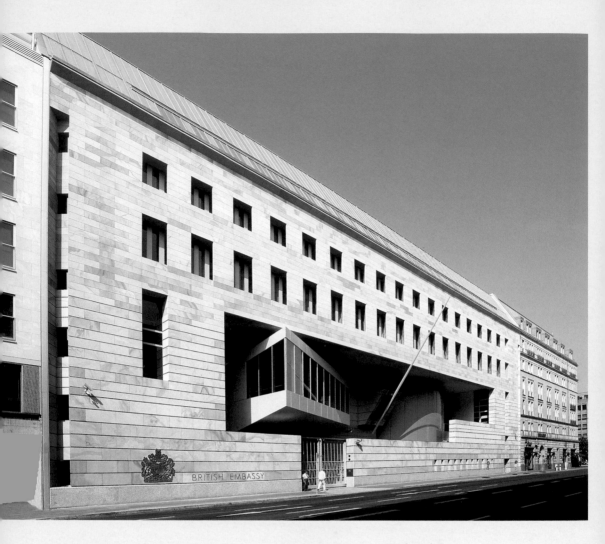

British Embassy

(Wilhelmstrasse)
Architect: Michael Wilford, London
1999-2000

The British Embassy located next to Hotel Adlon was constructed on the same plot it had prior to the Second World War. The building is one of the most interesting in Berlin. The sandstone facade looks at first glance quite conservative. Exceptional are the laterally perforated window openings as well as the sculptured metallic motifs in the drive way and entrance to the embassy. The architect designed a very futuristic facade for the inner courtyard by using a transparent glass-steel construction.

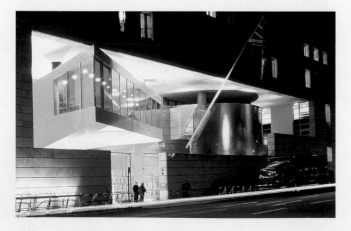

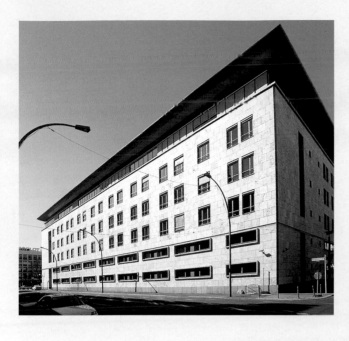

Office Building for Members of Parliament

(Unter den Linden 50/Neustädtische Kirchstrasse)
Architect: Alexander Kolbe, Berlin
1994-97

After being erected in 1965 for the GDR Ministry of Foreign and German Trade, the building was completely redesigned in 1994 -97. The main structure was restored and the facade was faced with natural stone bricks. The building was expanded by a glazed attic storey with a protecting roof.

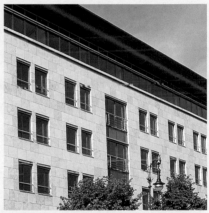

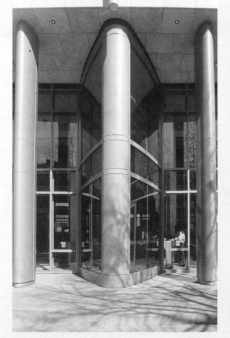

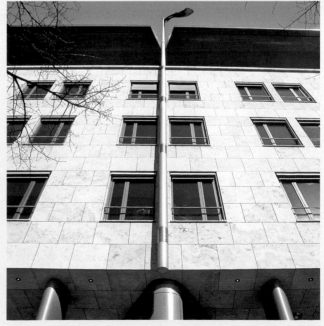

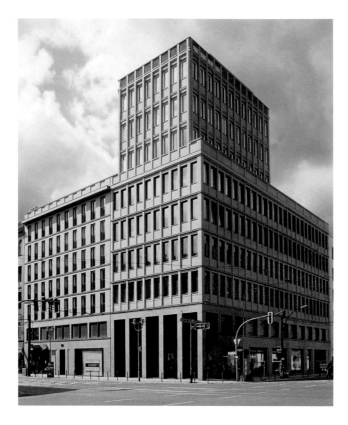

Residential and Commercial Buildings
(Friedrichstrasse 116, 119)
architects: Hans Kollhoff; Helga Timmermann, Berlin
1997-99

The two residential and commercial buildings were erected at the northern end of Friedrichstrasse at the former Oranienburg Gate. The street corner is accentuated by the three storey tower on the roof. The structure of the facade is typical for the designs of the architects Kollhoff & Timmermann. The facing of limb stone has a relief structure with small window openings and pilasters and cornices. The two bottom storeys form a high base.

Friedrichstrasse

Friedrichstrasse was laid out together with the new district Friedrichstadt from 1691 on. It was named after its founder, Elector Friedrich III., who became king Friedrich I in 1701. Formerly a residential area Friedrichstrasse was converted to a special shopping street with hotels, restaurants, shops and theaters. Some of the well-known establishments are e.g. "Café Kanzler", "Restaurant Kempinski", "Café Bauer" and the "Victoria Hotel". Friedrichstrasse runs over three and a half kilometers from north to south, crossing the river Spree, the grand boulevard Unter den Linden and Leipziger Strasse as well as the former Berlin Wall with Checkpoint Charlie.

Friedrichstrasse lost its former importance after 1945 due to the destruction caused by the Second World War and the erection of the Wall. An exception is the area near the Friedrichstrasse railway station. The decision to rebuild the southern part of Friedrichstrasse was not made until 1984. Some buildings were completed 1989. They were blown up a short time later in favour of new projects for the capital.

After the fall of the Wall in 1989 and the reunion in 1990 new plans were made to re-establish Friedrichstrasse as the cultural and commercial center of Berlin. Urban developmental planning focused on a "Kritische Rekonstruktion" of the historical plot structure. This meant that the historical aligment of the streets and plazas as well as the historical eaves height of 22 meters and a total height of 30 meters, including the roof, had to be taken into account.

Since the investors came from the commercial sector, Friedrichstrasse was almost completely rebuilt in 1999. Most of the buildings are commercial and residential ones with shops and restaurants on the ground floor and offices on the upper storeys. The top floors are used as apartments.

Office Building

(Friedrichstrasse 106-108/Ecke Johannisstrasse)
architects: gmp (von Gerkan, Marg & Partner), Hamburg
1997

The well-known architects of gmp designed a new type of corner building like this one, the Salamander House in Tauentzienstrasse (see p. 133) and the Atrium Friedrichstrasse (see p. 59). These buildings have a corner tower and are dominated by transparent facades and a visible supportive structure.

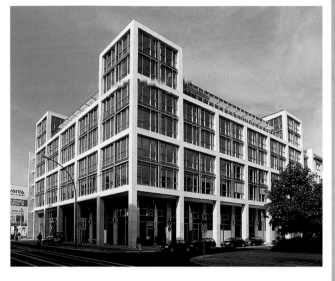

Dussmann Building

(Friedrich-/Dorotheen-/Mittelstrasse)
architects: Miroslav Volf, Saarbrücken
1995-97

Between Friedrichstrasse railway station and Unter den Linden new buildings faced with sandstone were erected and integrated perfectly into the historical surroundings. The building`s outline is typi- cal for the new architecture along Friedrichstrasse: The base of the building is formed by two-storey arcades. It is followed by four uniform designed full storeys and two staggered attic storeys. Remarkable is one room with a multi-storey shopping area (see illustration below).

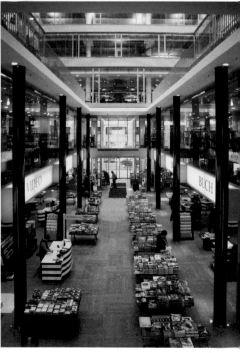

Wintergarden Block

(Friedrichstrasse 143-149)
Architects: Nalbach & Nalbach, Berlin
2000-02

The block near the Friedrichstrasse railway station harks back to the legendary "Wintergarten" night club.

Below:
Hotel Maritim

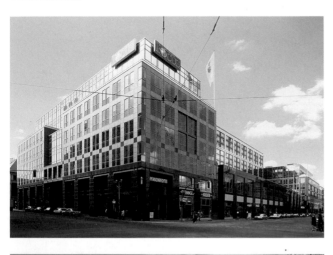

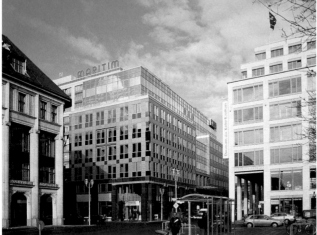

Friedrich Carree

(Friedrichstrasse 144-148, Dorotheenstrasse 57-60, Georgenstrasse 24-27)
Architects: Assmann, Salomon & Partner; Becker, Gewers, Kühn & Kühn; Eike Bekker Architekten; Müller & Reimann; Walter A. Noebe, Patzschke, Klotz & Partner; Metz, Klotz & Partner
2000-02

Like the projects Hofgarten (s. page 51, 52) and Kontor House (s. page 58) this block was erected according to a modular system. The over all organization and planning of the whole quarter was carried out by one office (Assmann, Salomon and Scheidt). The quarter was divided into many small plots. Each building was designed by a different architect. The facades share the same two storey bases, eaves height of 30 meters and a facing of natural stone.

Hotel Maritim

(Mittel, Friedrich, Dorotheenstrasse)
Architects: Nettbaum & Partner
1993-97

The monumental Hotel Maritim next to the Friedrichstrasse railway station is based on the former Hotel "Metropol" which was erected in 1977. The architects Nettbaum & Partner altered and expanded the GDR building according to the "Kritische Rekonstruktion"-concept. The new blocks are contemporary in style, and the historical alignment and the architecture of the Dussmann Building (see page 47) with its two storey arcades and terraced top floors. The old building (of the 1970s) can only be seen at Dorotheenstrasse, where it has a new glass facade.

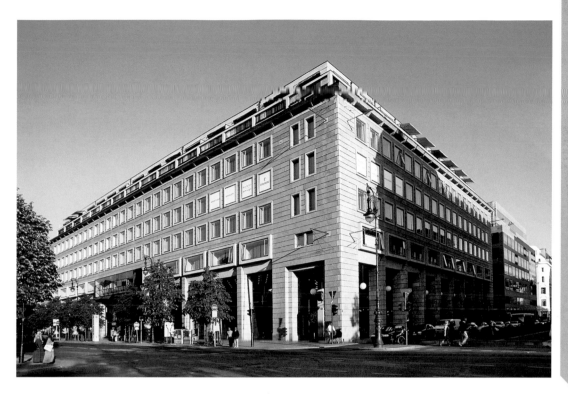

Lindencorso
(Corner Unter den Linden, Friedrich-
strasse/Rosmarinstrasse)
Architect: Christoph Mäckler,
Frankfurt/Main
1994-96

The Lindencorso was designed to serve
as a German and French center of com-
merce and culture with galleries and
shops. With its stone facade, brick work
structure and uniform window axes, the
building looks both modern and histori-
cal. For this reason it is conservative and
monumental. The apartments are loca-
ted in the three attic storeys.

Rosmarin Carree
(Friedrich, Behren, Charlotten, Rosma-
rinstrasse)
Architects: Böge & Lindner-Böge,
Hamburg
1995-98

The unornamented monumental block is
structured according to traditional prin-
ciple. The ground floor has arcades along-
side the street. The full storeys have a
transparent surface like the terraced top
floors.

Above: Lindencorso

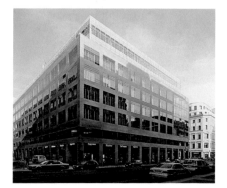

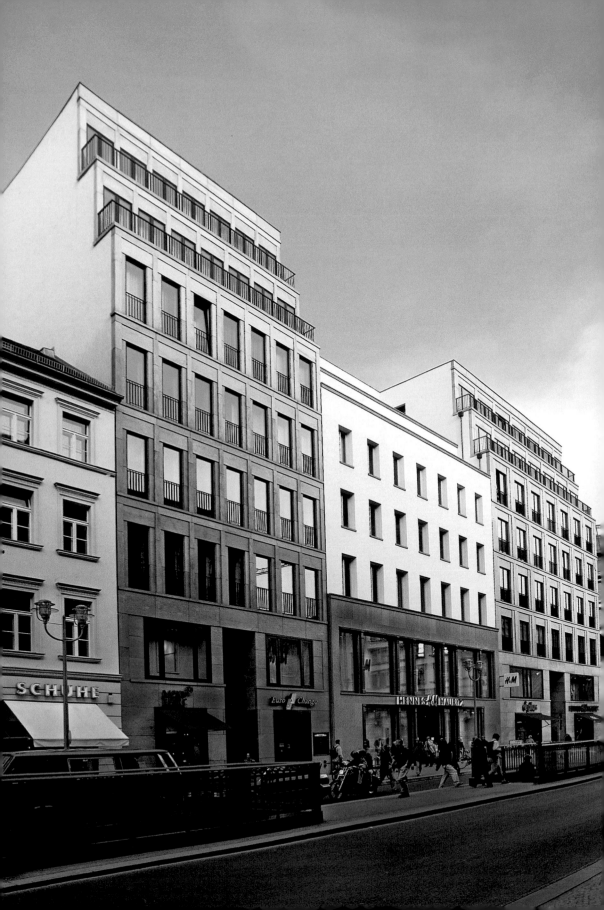

Hofgarten
(Friedrich, Französische, Charlotten, Behrenstrasse)
Architects: Josef Paul Kleihues, Berlin (overall concept, Hotel Charlottenstrasse, Bürogebäude Behrenstrasse); Max Dudler, Zürich/Berlin (residential building Behrenstrasse); Hans Kollhoff, Berlin (office building Friedrichstrasse); Jürgen Sawade, Berlin (office and commercial building Französische Strasse)
1993-96

The block was constructed according to a modular system by the architect Josef Paul Kleihues who wanted to revive the historical plot structure. Kleihues was responsible for the overall concept and two building designs, the inner courtyard and main entrances. The other buildings were designed by three important architects. For this reason the facades have different styles emphasized by various colored stone or rendered wall: The historical buildings dating back to around 1900 were integrated and add to the different facade structures. The apartments were integrated in one building. This differs from the other new buildings where the apartments are located in the attic storeys.

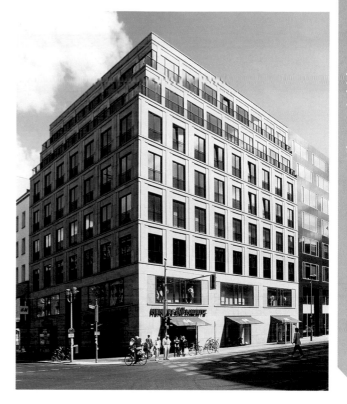

P. 50, 51: The new buildings constructed by Hans Kollhoff fit perfectly into the historical block structure. The facades are characterized by good proportions overall and in detail. The design is very individual. Kollhoff used slender window openings, a relief-type subdivision with pilasters and cornices as well as staggered roof storeys. The grey-green mottled granite is also striking, as it stands in direct contrast to the black window frames and balustrades.

Right: To the left of the historical corner buildings is the rather unspectacular new building on Behrenstrasse which was designed by Max Dudler. The dark granite facing and the uniform, horizontal window bands are not imposing.

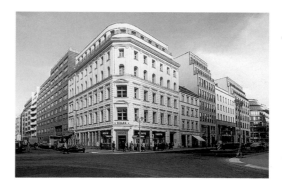

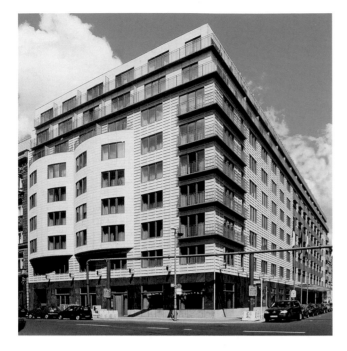

Below and above: Hofgarten
Above: Josef Paul Kleihues designed the luxury hotel of the Canadian Four Season-Group by Charlottenstrasse. The building extends over the entire width of the block. The facade is characterized by the use of Roman travertine stone, horizontal window openings and curving bays.
Below: Jürgen Sawade, whose work combines plain modern architecture with precious materials, used a grey-black polished granite facing for the office and commercial building on Französischen Strasse. He designed a uniform facade which looks very monumental with its horizontal window openings. It forms a contrast to the historic Neo-renaissance building "Restaurant Borchardt".

Josef Paul Kleihues

Kleihues' concept of urban developmental has left its mark on the Berlin architecture of the 1980s and 1990s. Born in Rheine, Westfalia, in 1933, Kleihues studied in Stuttgart, Berlin and at the École des Beaux-Arts in Paris. In 1962 he established his own office in Berlin. In 1973 he was appointed a professor at the University of Dortmund and since 1994 he is professor at the Art Academy in Düsseldorf. He held visiting chairs at the Cooper Union/New York and Yale-universities.
His most well-known projects are the Museum for Pre-history and Ancient History in Frankfurt/Main (1988), the Deichtorhallen in Hamburg (1988/89) and the Museum of Contemporary Art in Chicago (1996). A lot of buildings in Berlin were designed by him. Worth mentioning are the Berliner Stadtreinigung in Tempelhof (1969-83), the Kantdreieck (1995) (see page 136), the alteration and expansion of the Hamburg train station in Berlin (1996), the buildings at the Brandenburg Gate (1996-98) (see page 38), the Kontorhaus (1997) (see page 58), the Hofgarten (see page 51, 52) and the Triangel (1996) (see page 61).
Kleihues is Berlin's most influencial architect of 1980s and 1990s. This is why he organized and managed the IBA = International Architecture Exhibition 1984/87 since 1979. He guided the architecture of the late 1980s into a new dimension of urban developmental by creating and carrying out the concept of the "Kritische Rekonstruktion". This principle applied till the end of the 20th century. Even his suggestion to maintain an eaves height of 22 meters and to use terraced floors at heights of up to 30 meters became mandatory.

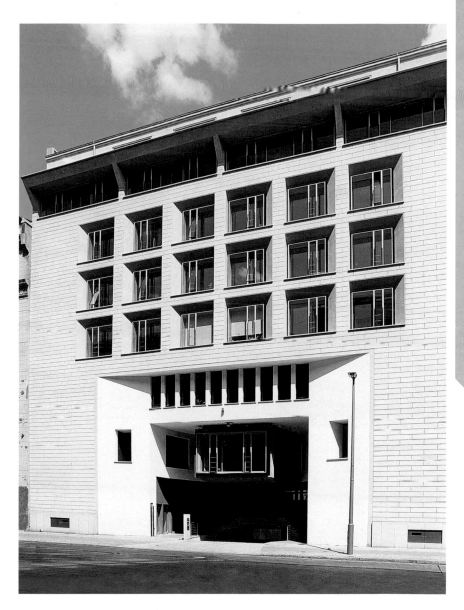

Office Building KPMG
(Taubenstrasse 45)
Architect: Christoph Mäckler,
Frankfurt/Main
1996-98

The eight storey building with sandstone facing fits perfectly between two historic houses. The symmetrical facade has a relief structure created by the three storey portal, deeply recessed window openings and an additional dominant attic storey. Besides that there is a rustic-like sandstone surface which makes the building imposing and innovative. The symmetric ground plan follows traditional designs with the main building towards the street, while the side wings and the inner courtyard are separated from the side wings by a transparent glass wall.

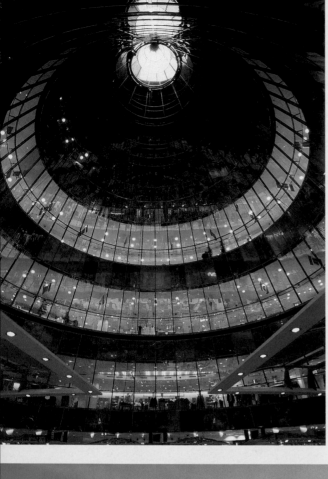

Friedrichstadt-Passagen

Between Gendarmenmarkt and Friedrichstrasse there are three blocks named "Friedrichstadt-Passagen", which were designed by Oswald Matthias Ungers (Quartier 205), Pei, Cobb, Freed & Partners (Quartier 206), and the "Galeries Lafayette" by Jean Nouvel (Quartier 207). They are connected below the ground level by a pedestrian passage. The quarters 206 and 207 at Gendarmenmarkt were already restored in the early 1980s. The other GDR buildings were demolished in 1992 in favour of the new projects.

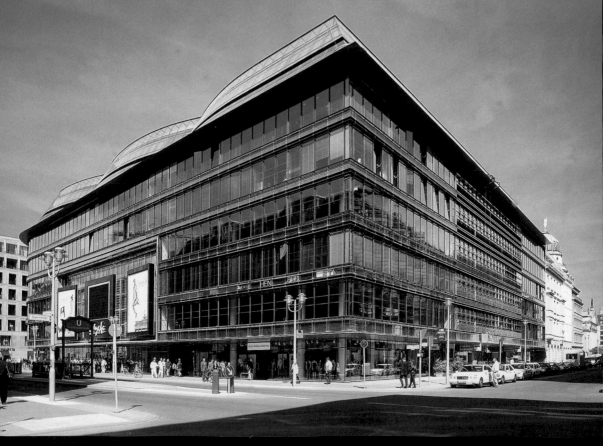

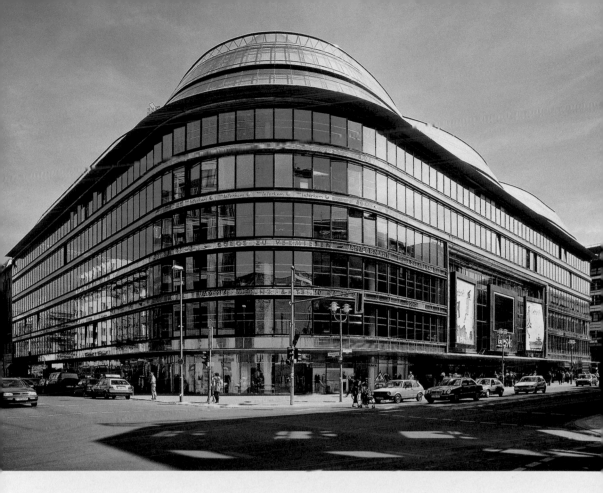

Galeries Lafayette
(Friedrichstrasse 75)
Architect: Jean Nouvel, Paris
1993-96

One of the most exceptional buildings is the French shopping building "Galeries Lafayette" with its full glass facade which is curved at the north-west corner. The facade reflects its surroundings in nice weather, while the brightly illuminated interior rooms stand out in darkness. Like the facade, the interior is also impressing with its glass architecture. Different sized glass cones are thrust through the building, with the point facing either downwards or upwards, sometimes spanning several storeys, sometimes only a few. The glass reflects countless of lamps which create a bizarre light.
Jean Nouvel, born 1945 in southern France, enjoys working with glass and light to create transparent and immaterial struc-

tures. He became famous by designing the building of the Institute du Monde arabe (1987) next to Notre Dame in Paris,

Quartier 205
(Friedrichstrasse 66-70/Charlottenstras-
se 57-59/Mohrenstrasse 46-50/Tauben-
strasse 14-15)
Architects: Oswald Mathias Ungers &
Partner, Köln/Berlin
1992-96

The architect Ungers from Cologne re-
ceived the biggest project of the Frie-
drichstadt-Passagen. He was commis-
sioned to design the whole block of
Quartier 205 from Friedrichstrasse to
Gendarmenmarkt, an area measuring
110 x 77 meters with approximately
53.000 square meters for offices, shops
and apartments. Ungers designed a
sandstone faced building which is based
on the square structure. The core con-
sists of a large, eight storey solid block
with two atriums which provide light to
the internal areas and around which six

square-like buildings were grouped. The
core differs from the rest of the architec-
ture through lighter sandstone facing.
Besides that the architecture is also
composed of cubic block structures and
square window openings.

Oswald Mathias Ungers

Ungers' architecture is dominated by the square. It gives his buildings harmony, beauty, clearness and calmness. Needless to say it also forms his designs in Berlin: the quartier 205 (see page 56) and the Tempelhof Family Court (1994) (see page 103) are two examples. Born in 1926, Oswald Mathias Ungers is one of the most successful German architects. He studied at the university in Karlsruhe as a pupil of Egon Eiermann (e.g. Langer Eugen in Bonn and Kaiser-Wilhelm-Memorial Church in Berlin). In 1950 he opened up his own office in Cologne. In 1963 Ungers became professor at the TU Berlin, in 1967 he went to the United States where he held visiting chairs at the Harvard University and the University of California. He eventually lectured at the Art Academy Dusseldorf from 1986 till 1991. He designed e.g. the German Architectural Museum in Frankfurt/Main (1979-84), the Badische Landesbibliothek (library) in Karlsruhe (1980), the halls 9 and 10 as well as the Torhaus (Gate House) on the premises of the Frankfurt Exhibition Center(1981-86), the residence of the German Embassador in Washington (1994) and the expansion of the Kunsthalle in Hamburg (1997).

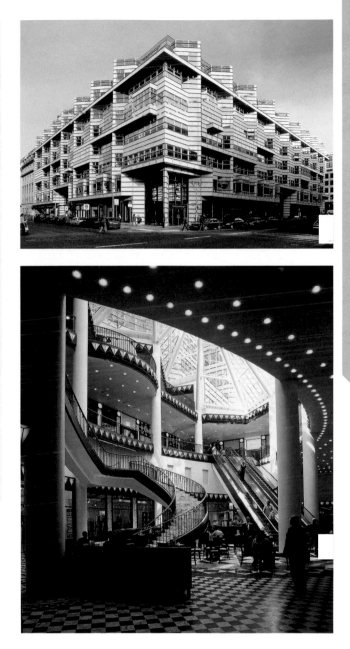

Quartier 206
(Friedrichstrasse 71-74)
Architects: Pei, Cobb, Freed & Partners, New York
1992-96

Totally different from the other buildings on Friedrichstrasse is the middle block between Tauben and Jägerstrasse. The monumental building is characterized by its bay-type elements, prismatic plasticity with an expressive network structure. This architecture reflects the motifs of the Berlin architecture of the 1920s which are interpreted in a totally new way. The corners of the bays are used as lamps. Remarkable is the inside with its atrium and the decoration of the passage with mosaics and curved stairways.

Kontorhaus Mitte (Counting House)

(Friedrichstrasse 180-190, Mohrenstrasse 13-16, Kronenstrasse 60-65)
Architects: Josef Paul Kleihues, Berlin; Vittorio Magnago Lampugnani/Marlene Dörrie, Frankfurt a. M.; Walther Stepp, Berlin; Klaus Theo Brenner, Berlin
1994-97

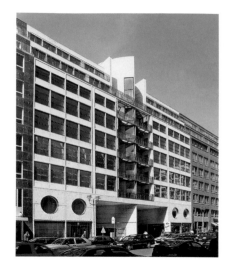

The new buildings extend over half of the block. They were erected by Josef Paul Kleihues using a modular system consisting of six plots that follow the small historic plot structure. This means that although there was an overall design principle, each facade was made to look distinctive. Here the "Kritische Rekonstruktion" was carried out for the first time, as shown the eaves height of 22 meters, a ridge height of 29 meters and staggered roof storeys, sandstone facing and alignment line that apparently respect the small plot structure (compare the introduction).

The four architectural offices were responsible for the designs of the respective buildings. The whole block has as uniformly functional conception with individually designed buildings. This was meant to guarantee that the new buildings follow the traditional architecture. Indeed the block has a more differentiated and individual appearance than the other block buildings on Friedrichstrasse which were designed by a single architect. Joint elements of the block buildings designed by Josef Paul Kleihues are the

inner courtyard and the staggered roof storeys with a uniform roof. The individual houses do not only differ due to different window forms but also because of different colors of sandstone facings. The most convincing buildings are the corner building Friedrich-/Kronenstrasse by Klaus Theo Brenner with small window openings, a two-storey ground floor and black polished granite facing.

Other facades show light or red stone facing material. The structure of the facades is rather similar because of the terraced top floors and a uniform eaves height.

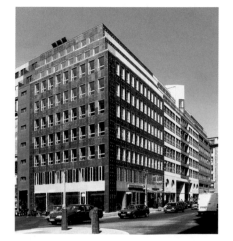

Atrium Friedrichstrasse

(Leipziger/Ecke Friedrichstrasse)
Architects: gmp (von Gerkan, Marg &
Partner), Hamburg
1995-97

The building is situated at a prominent
location in the middle of Friedrichstrasse.
The building structural elements are
visible in its facade. Like hardly any other
building it shows its construction by
differentiating the loadbearing framework
from the non-load-bearing parts (the
glass surfaces). The corner itself is accen-
tuated within the urban planning concept
by a tower. The 45 meter long atrium is
covered by a glass barrel roof.

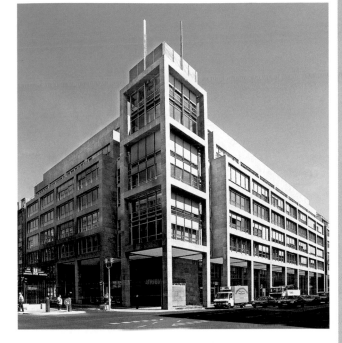

Office and Commercial Building
(Quarter 108)

(Friedrich-/Ecke Leipziger Strasse)
Architects: Thomas van den Valentyn,
Matthias Dittmann, Cologne
1996-98

This monolithic nine-storey block occu-
pies the corner at Friedrichstrasse/ Leip
ziger Strasse/Kronenstrasse. The buil-
ding is faced with dark stone material and
is strongly structured by a two-storey
gound floor (with large windows and
"barred" first full storey), four regular sto-
reys and three terraced floors at the top.

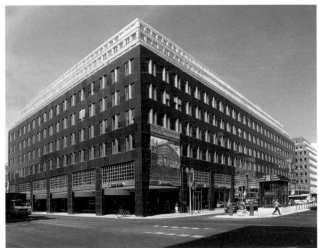

Hotel Astron

(Leipziger Strasse 106-111)
Architect: Klaus Theo Brenner, Berlin
1999-2000

The hotel presents itself in an unspecta-
cular way with its red and polished sur-
face.

Kronenkarree

(Kronenstrasse 1-7, Mauerstrasse 14)
Architects: Mann & Partner M + P, Mün-
chen/Berlin
1996-2001

Exceptional is the corner building Mauer-
strasse 14 with two glass storeys and cir-
cular conference room on top of the buil-
ding.

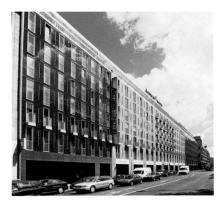

Hotel Astron

Philip-Johnson-House
(Friedrichstrasse 200/Mauerstrasse)
Architect: Philip Johnson
1994-97

The monumental block building (quarter 160) with its stern appearance is given rhythm by alternating glass structures and granite faced tower-like walls. The tower-like structure is visually tied together by a horizontal band above the sixth storey. The entrance areas are emphasized by a multi-storey laterally running glass-curtain motif.

It certainly is a peculiarity that a building is named after its architect while he is still alive. It is out of respect to the well-known star architect Philip Johnson who has influenced architecture since the 1930s. He is one of the most important architects of the 20th century.

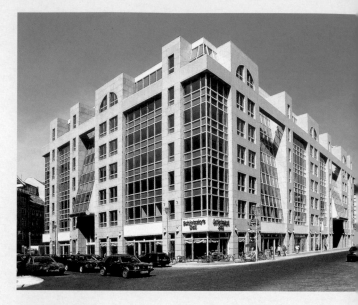

Office Building
(Friedrichstrasse 50/Krausenstrasse/
Schützenstrasse)
architects: Ulrike Lauber & Wolfram
Wöhr, Munich
1996-98

Located opposite to the Philip-Johnson-House this glass building has long window bands with a highly original elliptical corner.

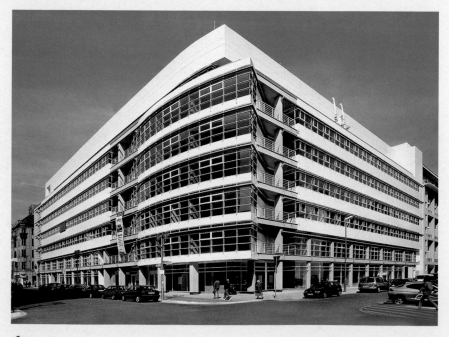

Office and Commercial Building Triangel
(Friedrichstrasse 204/Mauerstrasse)
Architect: Josef Paul Kleihues, Berlin
1994-96

The extraordinary office building was erected on a triangle shaped plot (therefore the name "triangel"). The building follows the old lines of alignment. At the sharp edged street corner of Mauerstrasse and Friedrichstrasse the building is rounded. Towards Mauerstrasse the third to seventh full storeys are formed like a fully glazed bay while the other storeys are faced with granite and structured by horizontal window bands. Remarkable is the sharp edged steel glass structure pointing towards the Checkpoint Charlie.

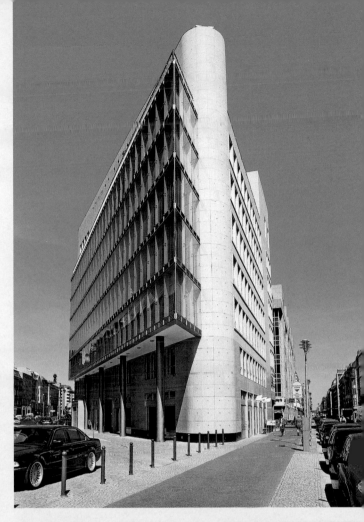

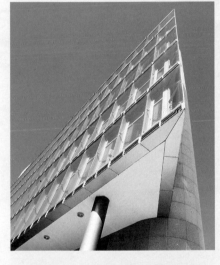

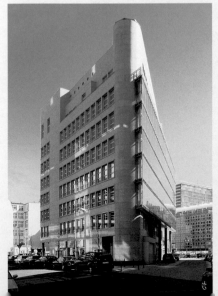

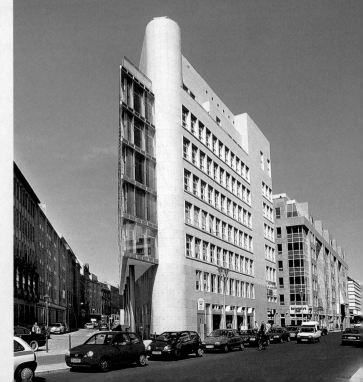

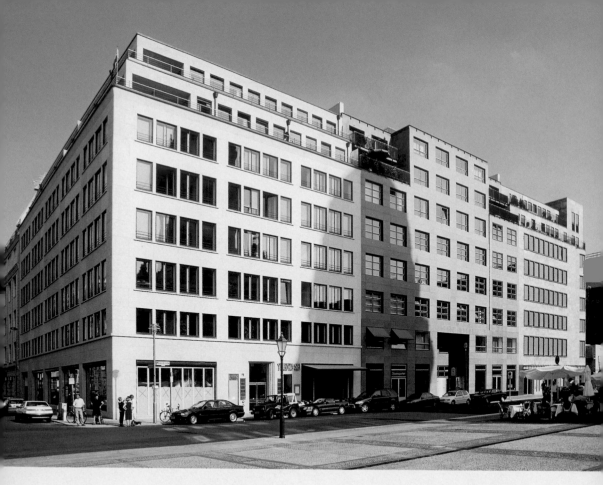

Above:
Markgrafenstrasse
36, 35, 34

Right:
Markgrafenstrasse
35 (detail)

Gendarmenmarkt

**Office, Residential and
Commercial Building**
(Markgrafenstrasse 36)
Architects: Hilmer & Sattler, München
(Heinz Hilmer and Christoph Sattler)
1994-96

The corner building at Tauben-/Markgra-
fenstrasse adopts the terraced attic sto-
reys used in the neighboring building by
Max Dudler and in number 34 by Klei-
hues. The windows are small and rhyth-
mically structured. The high ground
floor with its big windows forms a
ground base for the clear and unadorned
facade of the full storeys.

Office, Residential and Commercial Building

(Markgrafenstrasse 35)
Architect: Max Dudler, Zürich/Berlin
1994-97

Facing the Deutsche Dom at Gendarmenmarkt, this building's facade is clear and strongly symmetrical. It shows the typical plain forms, as well as strong, sharp and cubic structure of the buildings designed by the Swiss architect Max Dudler. The windows are oblong, the two outermost window axes of the two floors at the top are terraced. This emphasizes the four middle window axes and the two storey entrance portal. The symmetrical facade is faced with dark granite bricks which have noticible steel screws. The motif of the steel screws which were also used by Josef Paul Kleihues are designed to show that it is not a real stone facade but a brick construction.

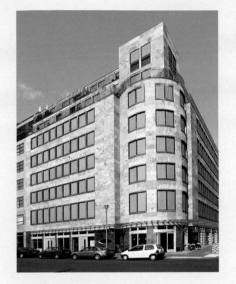

Left:
Markgrafenstrasse 34

Below:
Markgrafenstrasse 36, 35

Office, Residential and Commercial Building

(Markgrafenstrasse 34)
Architect: Josef Paul Kleihues, Berlin
1994-96

Although the corner building Mohren/ Markgrafenstrasse shows the same sto-

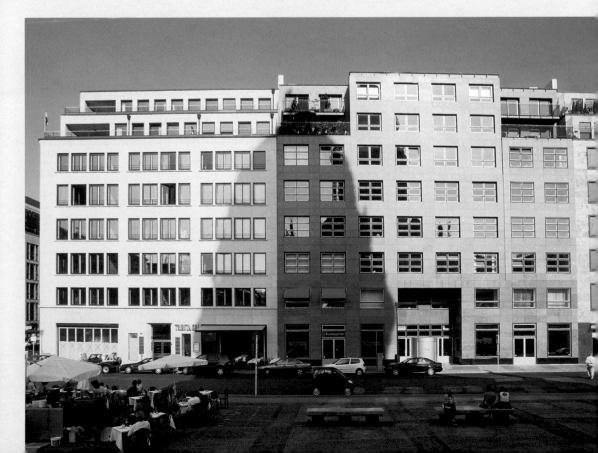

rey structure as the building at the corner of Tauben-/Markgrafenstrasse, the facade structure does not appear "classically modern" because of the uniform, horizontal window bands. They are inspired by the architecture of the 1970s and 1980s. This also applies to the corner tower which appears strange and can already be found in Berlin architecture of the 1980s.

Federal Ministry of Justice
(Jerusalemer 24-28, Mohrenstraße 36-37b, Kronenstraße 38-41)
architects (Extension Building and Alterations): Eller + Eller, Düsseldorf
1997-2001

The Federal Ministry of Justice is located in a complex composed of buildings dating from different times: four 100 year old buildings which are protected monuments, the famous Mohren Colonnades by Carl Gotthard Langhans (1787), one big GDR-building and in the courtyard a new cubic-straped building that now houses the library (illustration below). All of the buildings are linked to one another and form a variated complex which respects the historical plot structure. Two of the five inner courtyards were covered by a glass roof.

Office Center at the Ministry of Foreign Affairs
(illustration top right)
(Hausvogteiplatz 13/Niederwallstraße 1-2)
Architects: Christoph Czarniak, Wiesbaden
1998-99

The new building respects the eaves height of the old building next to it by Alterthum & Zadek (1895). It is influenced by Baroque and other historical forms as can be seen in the roof, the mezzanin storey and the symmetrical facade structure.

Federal Ministry of Justice

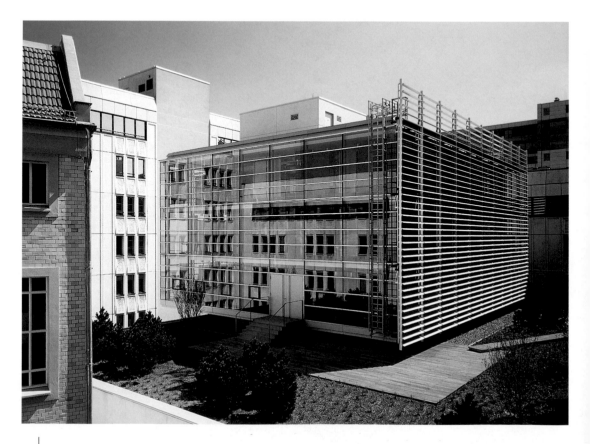

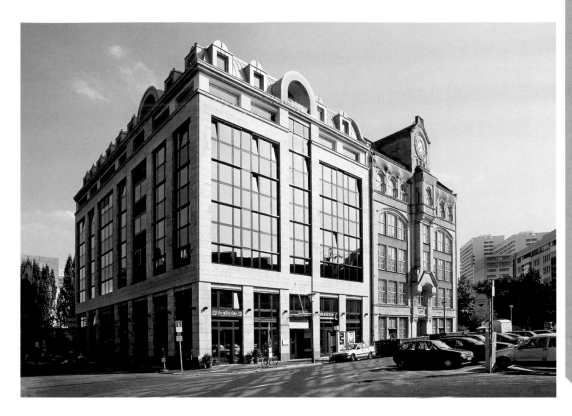

SAT 1 Broadcasting Centre
(illustration right)
(Oberwallstrasse 6-7/Jägerstrasse 27-33/ Taubenstrasse 24-25)
Architects: Dieter Hoffmann, Frank Uellendahl, Berlin
1995-2000

The broadcasting channel SAT 1 is located in several new and old buildings near Gendarmenmarkt. Remarkable is the new glass roof on top of the old shopping building of 1896 which was designed by the architects Bohm & Engel.

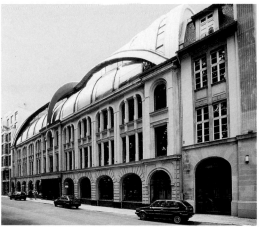

Wissenschaftsforum Berlin
(Berlin Science Forum)
(Markgrafenstrasse 37/Taubenstrasse 30)
Architect: Wilhelm Holzbauer, Vienna
1996-98

The corner building at Gendarmenmarkt opposite to the Schauspielhaus (theater) by Schinkel has the same eaves height ridges and rustic wall as the historical buildings in its vicinity.

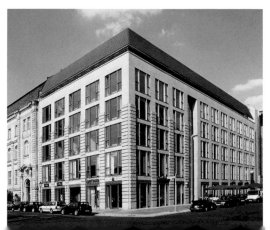

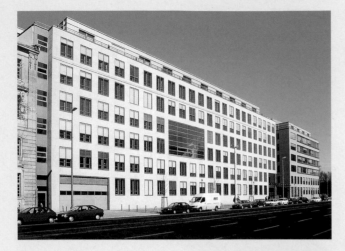

Deutscher Industrie- und Handelstag, Bundesverband der Deutschen Industrie (BDI), Bundesvereinigung der Deutschen Arbeitgeberverbände (BDA)
(Breite Strasse 20-21/Gertraudenstrasse)
Architects: Schweger + Partner, Hamburg/Berlin
1997-99

The Berlin headquarters of the leading organization of German commerce and industry is an impressing building consisting of three differently designed structures which are connected by a atrium.

Ministry of Foreign Affairs
(illustrations p. 67)
(Werderscher Markt/Kurstrasse 36)
Architects: Thomas Müller, Ivan Reimann
1997-99

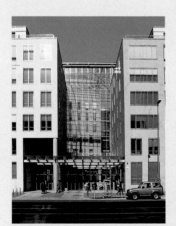
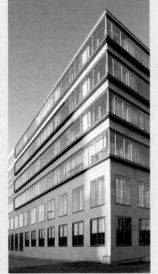

The German Foreign Ministry is located on Werderscher Markt in the former Reichsbank Building and in a massive new cubic structure with large courtyards. The courtyard which opens to the north is a semi-public glass-roofed plaza. The second courtyard with the library is used as a garden. The courtyard to the south is formed like a court of honor.

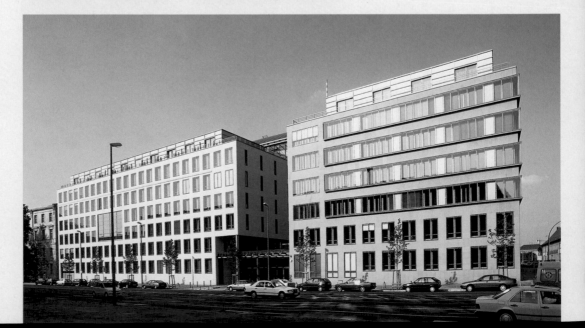

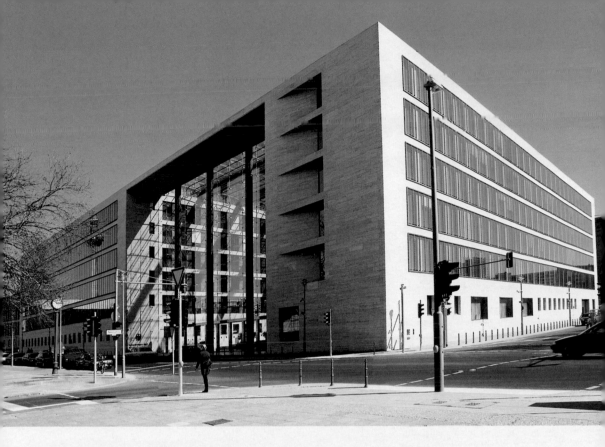

Ministry of Foreign Affairs (extension building)

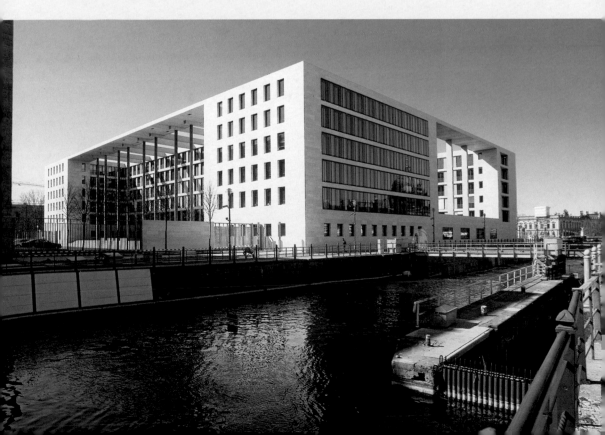

Quarter Schützenstrasse
(Schützen-/Markgrafen/Zimmer-/
Charlottenstrasse)
Architect: Aldo Rossi, Mailand
1994-97

A curiosity within Berlin`s new archi-
tecture is the plot bounded by Schützen-
strasse, Zimmerstrasse, Markgrafen-
strasse and Charlottenstrasse. It was
part of the Berlin Wall complex. The ar-
chitecture appears colorful and variated
and is combined with a lot of historical
motifs. The renowned architect Aldo
Rossi (1931-1997) from Milan respected
the traditional narrow small plot and
backyard structure. The buildings create
the illusion of being erected over a long

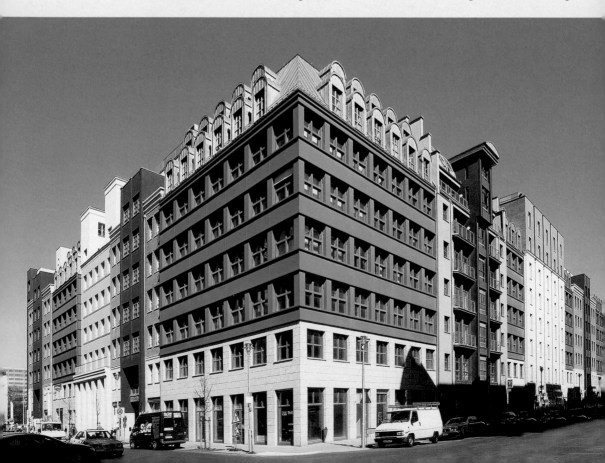

period of time although this is only applicable for some buildings. One facade is a copy of the Palazzo Farnese (1514-1546) in Rome by Λ. da Sangallo the Younger and Michelangelo (illustration p. 68 top left). A lot of other details are also historical elements like pilasters, cornices, window frames, etc. The link to tradition also becomes visible through the proportions and variations of the roofs, staggered facades and bases.

Left:
Axel Springer
Verlag

Page 71:
GSW Tower

Axel Springer Verlag
(Kochstrasse 50/Charlottenstrasse/Axel-Springer-Strasse)
Architects: Franz Heinrich Sobotka, Gustav Müller (1961-66), Gerhard Stössner, Thomas Fischer, Berlin (1992-94)
1961-66, 1992-94

The nineteen-storey building is 68 meters high. It was constructed in the 1960s and extended in 1992-94 by the addition of a slab-like glass tower block. The editorial office of the newspaper "Die Welt" moved from Hamburg to Berlin and is located in this building.

GSW Tower (Gemeinnützige Siedlungs- und Wohnungsbaugesell-schaft mbH, Berlin)
(Kochstrasse 22)
Architects: Matthias Sauerbruch and Louisa Hutton, Berlin 1995-99

The GSW extension is a good solution by the architects Sauerbruch and Hutton. They were commissioned to combine three extension buildings with an existing administrative tower dating from the 1950s. The new, dominant twentyone storey tower with a glass facade is connected to the old tower along its entire height. The slim new building with its curved layout is impressive because of its steel-glass construction as well as its transparency and ecological concept. It is the first tower building in Europe possessing a double glass facade which reacts to different external temperatures and light levels, enabling energy consumptions to be by 40 %. The colored slats of the glass facade create a daily changing appearance. The other new three-storey high building with the old street alignment has a round green tower at the corner at Koch-/Markgrafen-strasse.

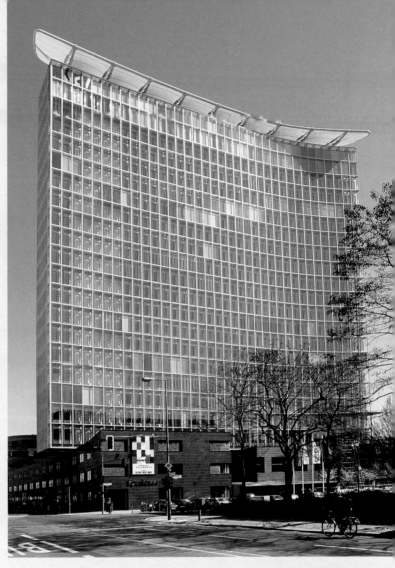

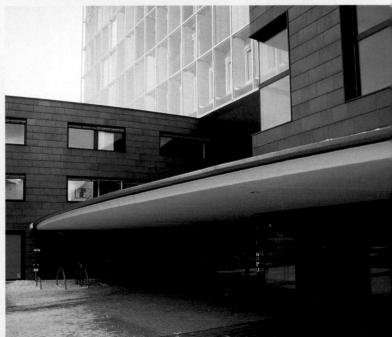
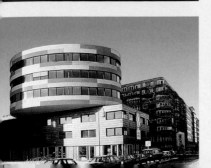

Representative Office of Rhineland-Palatinate

(Allee in den Ministergärten)
Architects: Heinle, Wischer und Partner, Stuttgart
1999-2000

The building with a three-winged structure has an asymmetrical facade and ground-plan.

Representative Office of Lower Saxony and Schleswig-Holstein

(Allee in den Ministergärten)
Architects: Cornelsen + Seelinger, Seelinger + Vogels, Amsterdam, Darmstadt
1999-2000

The six-storey building has a central joint multifunctional glass hall which is flanked by rooms and apartments for each of the neighbouring states.

Above: Representative Office of Rhineland-Palatinate
Below left: Representative Office of Saarland
Below right: Representative Office of Lower Saxony and Schleswig-Holstein

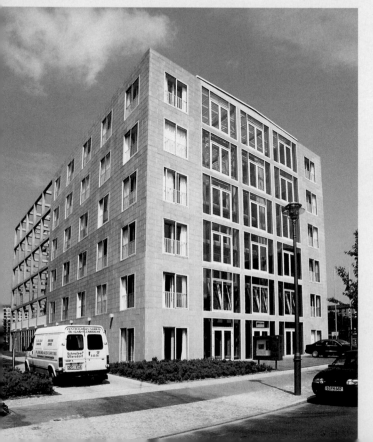

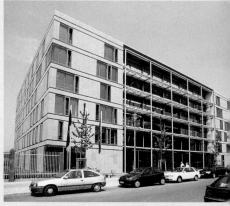

Representative Office of Saarland

(Allee in den Ministergärten)
Architects: Peter Alt und Thomas Britz, Saarbrücken
1999-2000

The building consists of two cubes which are designed complement to each other. While the middle section of the cube on the street side has been cut out, the other cube has rooms facing in the other direction.

Representative Office of Thuringia
(Mauerstrasse 54-55/Mohrenstrasse)
Architects: Worschech & Partner
1997-99

The compact, cubic-like corner building is structured by glass and light and green stone facing.

Representative Office of Brandenburg und Mecklenburg-West Pomerania
(Allee in den Ministergärten)
Architects: von Gerkan, Marg und Partner (gmp), Hamburg
1999-2000

Two individual blocks, one block for each state, were connected by a central glass hall which is intended for offical use by both representations.

Mosse Palais
(Leipziger Platz 15)
Architects: Hans D. Strauch/Gallagher, Boston
1995-97

The Mosse Palais was the first building of the new block complex at Leipziger Platz (towards the plaza and Vossstrasse). It is named after the Jewish publisher Rudolf Mosse who used to live at this location prior to the Second World War. The building is used by the American Jewish Commitee. The architecture is traditional and the Mosse Palais looks like buildings in New York and Chicago from the early 20th century.

Above left:
Representative Office of Brandenburg und Mecklenburg-West Pomerania

Above right:
Land representation of Thuringia

Right:
Mosse Palais

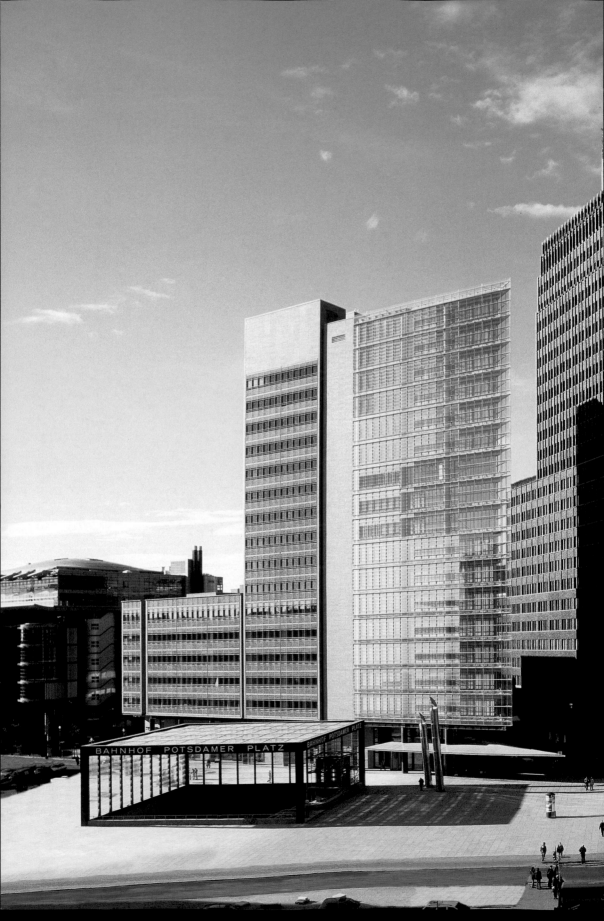

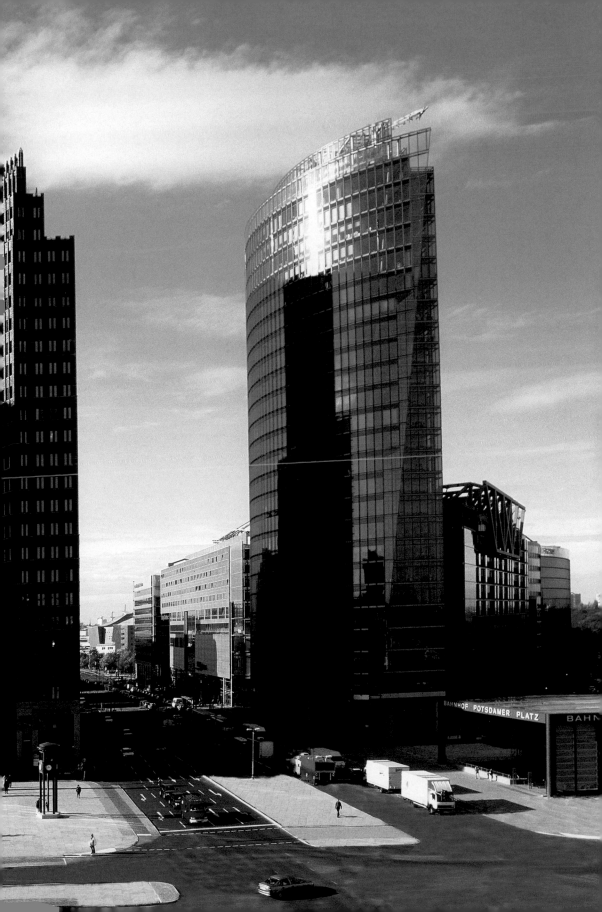

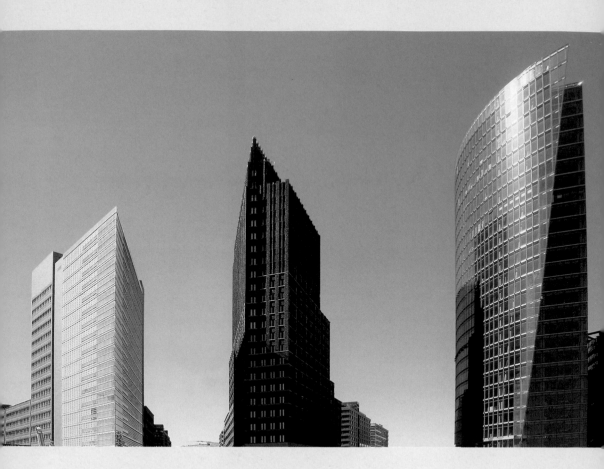

Potsdamer Platz

Potsdamer Platz is synonymous with the restauration of the city center and the reunification of West and East Berlin after 1990. The plan for the reconstruction of Potsdamer Platz which won the competition of 1991 favoured of dense construction at a medium height typcial of European cities and in contrast to that found in the United States. Only directly at Potsdamer Platz one finds houses of about 90 meters height, as a kind of eye-catcher in the urban landscape.

The new structure for Potsdamer Platz is a result of the publicly sponsored "Potsdamer/Leipziger Platz competition for urban design ideas" in 1991. 16 architural offices from all over the world were invited to develop a "plan for a mixture" of shopping, leisure, culture, business, and residential areas and office space in the style that has become usual since the 1980s. The "mixed use" should guarantee a busy and lively center the whole day long and should avoid monostructures.

The competition in 1991 was of international interest. Nowhere else did architects have such an opportunity to rebuilt an area covering 480,000 square meters in a city center. Besides there was the myth of the Potsdamer Platz. In the 1920s it was the plaza with the greatest traffic density in Europe.

Because of World War II and the Berlin Wall only two old buildings were conserved: the wine house Huth and parts of the Grandhotel Esplanade.

Hilmer & Sattler were the winners of the competition in 1991. They designed a dense, medium-height complex with alleys and squares in keeping with the style of a European city.

In the end, two different plans were implemented. In the southern Daimler-Benz area, detached houses were constructed between 1993 and 1999 in a combined modern traditional style covered with stone facing materials. The buildings were erected according to plans made by various architects. The northern Sony area, on the other hand, is based on a uniform masterplan by a single architect, the German American star architect Helmut Jahn. As a modern steel and glass complex built between 1996 and 2000 it stands in contrast to the surrounding area.

The Daimler-Benz area takes the proportions and building materials of the excellently designed Kulturforum into account. The 88-meter high building with its red brick facades (1994-99) was constructed by Hans Kollhoff & Timmermann at the northern end of the Daimler-Benz area at Potsdamer Platz and, together with the 103 meter high glass Sony tower by Helmut Jahn and the ocher colored and partially glassed office building by Renzo Piano, forms the striking high rise ensemble of Potsdamer Platz.

Potsdamer Platz regional railway station
Architects: Hilmer & Sattler, München/Berlin; Hermann + Öttl, Moderson & Freiesleben Architektengemeinschaft, Berlin
1995-2001

Two cubic steel and glass structures on square ground plan characterize the new subterranean regional railway station on Potsdamer Platz infront of the three skyscrapers. The station is on three levels for urban railway and subways while main-line services pass along the outer tracks. The Potsdamer Platz station is similar to the pre-war railway station which was the most important in Berlin before World War II.

DaimlerCrysler Site
(Potsdamer Strasse/Linkstrasse)
1993-99

In 1992 Daimler-Benz AG invited 14 architecture offices to design new buildings for the 340 square-meter DaimlerCrysler Area based on the concept drawn up by Hilmer & Sattler. Renzo Piano and Christoph Kohlbecker were the winners of the competition. Their design creates a link between the individual free-standing buildings of the Cultural Forum and the disciplined block development of the DaimlerCrysler Area including the skyscrapers at Potsdamer Platz. Besides they got the idea desig-

ning a small square (now Marlene-Dietrich-Platz) and water elements as well as the new "Old Potsdamer Strasse", which had become a cul-de-sac when the National Library was built by Scharoun in 1968. By following the historical street layout and designing a number of new streets Piano and Kohlbecker formed 19 blocks.

The architectural ensemble is given a striking high rise by the skyscrapers on Potsdamer Platz and the debis tower at the Landwehrkanal.

The DaimlerCrysler Site is composed of 50 percent office space, 30 percent shops, restaurants, bars and cultural amenities and 20 percent apartments. 10,000 people live and work in this area.

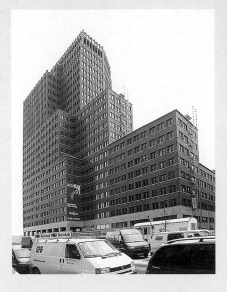

Office and Commercial Building

(Alte Potsdamer Strasse/Neue Potsdamer Strasse)
Architect: Hans Kollhoff, Berlin
1994-99

The 18-storey building is situated on the northern part of the DaimlerCrysler site at Potsdamer Platz and together with the Sony tower forms the extraordinary gateway to Potsdamer Strasse. Because of the dark-red clinker and granite facings, as well as the relief structure with small window openings, pilasters and cornices, the skyscraper is in sharp constrast to the transparent structure of the Sony tower. The ground floor is faced by green granite. The building descends like a flight of stairs to a height of 38 meters. Because of the building's

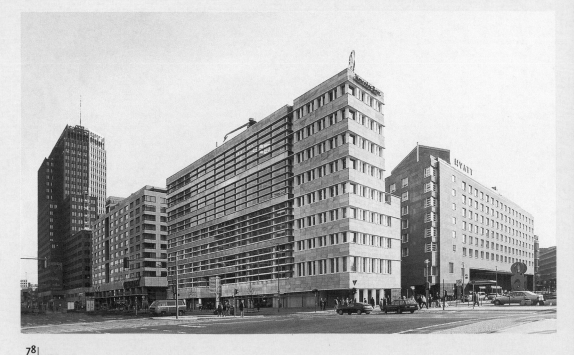

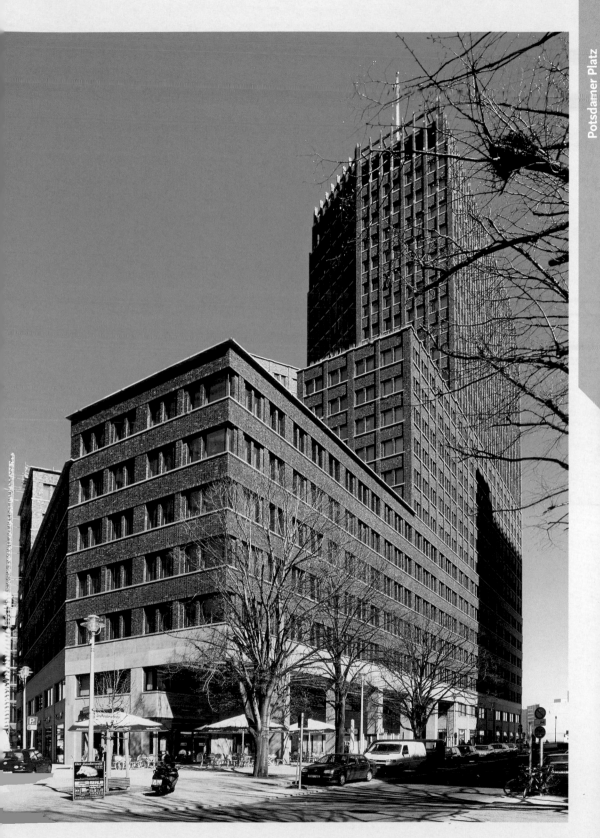

staggered structure the tower fits in well with the neighbouring buildings. On the roof of the 88 meter high building is an observation platform.
The facing and relief structure as well as the staggered design is modeled on the skyscrapers of the 1930s and 1940s in North America.

Office and shopping building
(Potsdamer Platz)
Architects: Renzo Piano, Paris and Christoph Kohlbecker, Gaggenau
1995-99

The eighteen-storey building between Alter Potsdamer Strasse and the new park was erected on a triangle shaped plot. It is one of the three skyscrapers which form a gateway at Potsdamer Platz. Like the debis tower, this building is faced with yellow-ocher terracotta bricks and glass elements. Impressing are the expressiv main entrance roof and the corner glass construction, which appears like the bow of a ship.

Potsdamer Strasse,
the Sony Site is on the left,
DaimlerCrysler Site is on the right.

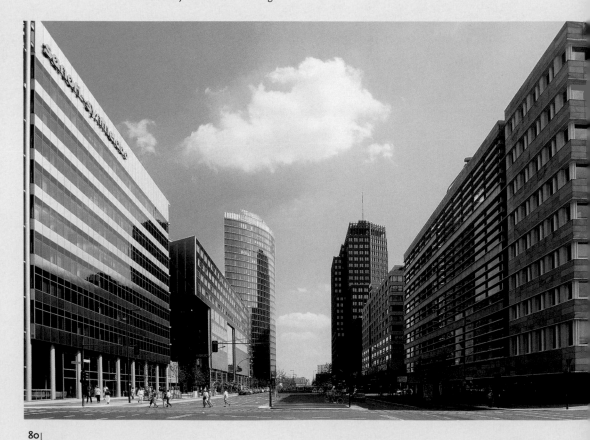

Hans Kollhoff

Few other architects are as much in demand in Berlin as Hans Kollhoff. His skyscraper design for Potsdamer Platz characterizes the city silhouette. Several more of his buildings can be found in other parts of Berlin, especially on Friedrichstrasse. Born in 1946 in Lobenstein in Thuringia, Kollhoff studied in Karlsruhe, Vienna and at Cornell University New York, as assistant to Oswald Mathias Ungers. Since 1984 he works together with Helga Timmermann in Berlin. He is a professor there since 1990 after having held visiting chairs in Berlin and Zürich. Hans Kollhoff is known for his conservative facade designs which are characterized by small window openings and sandstone facings. During the early 1990s he defended the "stone house" (in contrast to transparent facades). His doctrine for the reconstruction of the center of Berlin was adopted by Hans Stimmann, architectural director of the Berlin Senat. That is why Kollhoff became one of the most influencial architects in Berlin next to Josef Paul Kleihues. In addition, he was assigned in 1994 to draw up the concept for the alteration of Alexanderplatz.
New projects: Apartment buildings at the old harbor in Antwerp; skyscrapers with apartments in Frankfurt/Main; Delbrück-Bankhaus, Berlin-Mitte.

Renzo Piano

The Italian architect Renzo Piano won the competition for the rebuilding of the Daimler-Benz area at Potsdamer Platz in 1992. He also influenced the design of the new city center by creating the two skyscrapers as well as the musical theatre and casino near Potsdamer Platz.
Born 1937 in Genoa he became famous for his participation in the design at the Centre Pompidou in Paris, a joint project with Richard Rogers (1977).

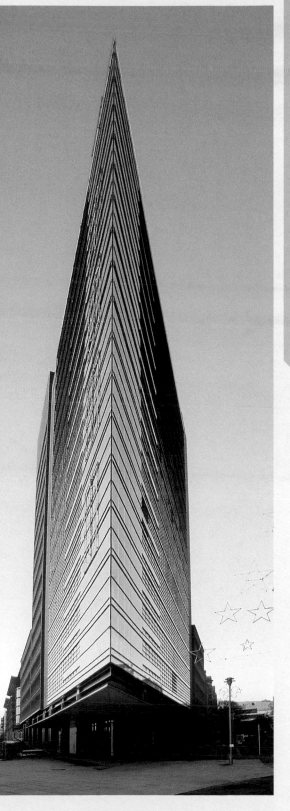

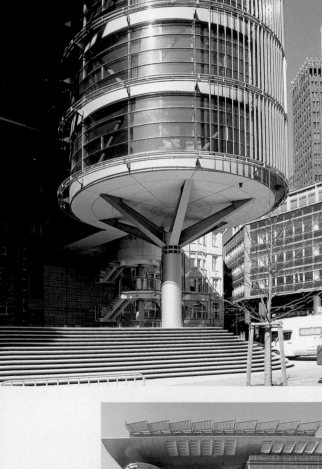

Office, Residential and Commercial Buildings
Linkstrasse
Architect: Sir Richard Rogers, London
1995-1998

The design of these three commercial, office and apartment buildings seems futuristic. They are located on Linkstrasse along with a park on the site of the former Potsdamer railway station. The architect Richard Rogers is mainly known for designing the Centre George Pompidou in Paris, a joint project with Renzo Piano (1971-77). Renzo and Rogers went separate ways after the completion of the famous museum building and only met again during the development of the debis area. The floor space of the 3 uniform buildings is 55 x 53 meters each, the height is 37 meters with seven storeys (eaves height 27 and 29 meters).

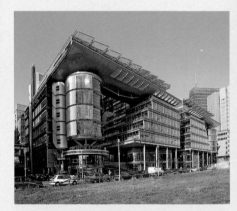

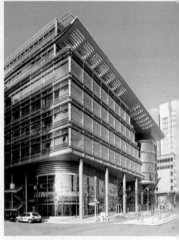
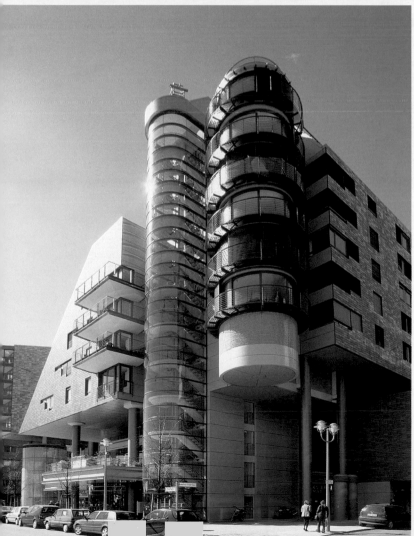
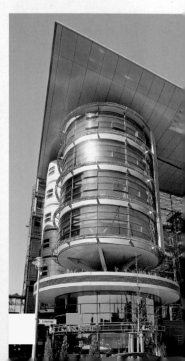

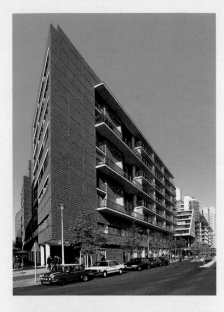

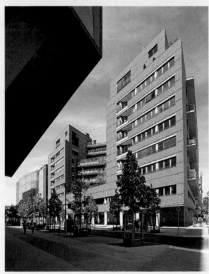

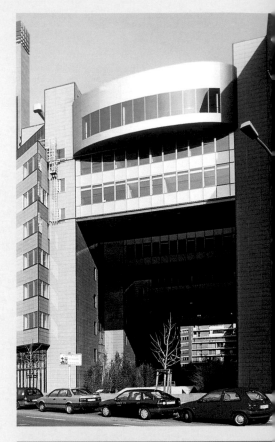

Residential Building "Grimm-House"
(Eichhornstrasse/Linkstrasse)
Architects: Ulrike Lauber/Wolfram Wöhr,
Munich

The building is faced with red terracotta
stones and contains apartments, shops
and a kindergarten.

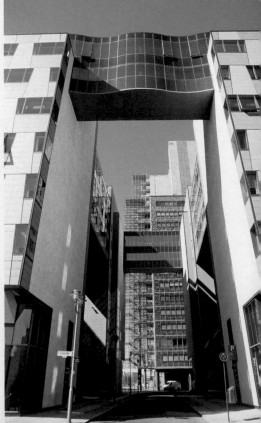

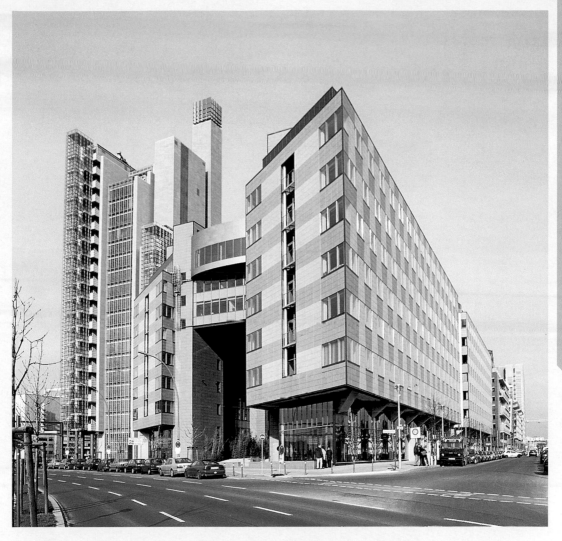

Headquarters of the Berliner Volksbank
(Linkstrasse/Reichpietschufer)
Architects: Arata Isozaki, Tokyo; Steffen
Lehmann, Berlin
1994-98

The administration of the Berliner Volks-
bank forms two blocks which are located
away from the busy streets of the Daim-
ler-Benz area.1,200 people work here.
The parallel building structures are
crossed from north to south by Schel-
lingstrasse. The blocks are linked by five
three-storey bridge-like passages. The
area between the blocks is designed as a
park. The brown and ochre bands along
the walls as well as the windows create a
horizontal and vertical facade structure.
The facades of the transparent ground
floor, the staggered roof storeys as well
as parts of the park are curved.
The building was designed by one of the
most well-known Japanise architects:
Arata Isozaki, born in 1931.

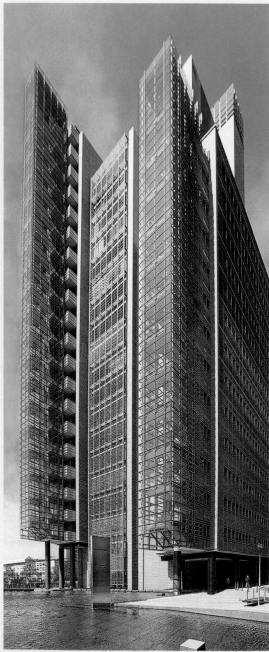

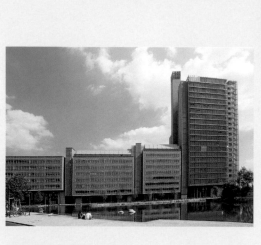

debis Headquarters
(Reichpietschufer/Schellingstrasse/Eichhorn-
strasse)
Architects: Renzo Piano, Paris; Christoph Kohl-
becker, Gaggenau
1994-97

The debis headquarters is located on a long plot in
the southern part of the DaimlerCrysler site. It is
formed by a 60 meter high tower with the debis
logo on the roof and two elongated wings of ad-
ministrative buildings that encompass the glass-
covered atrium, which is 90 meters long,
14 meters wide and 33 meters high. The buildings
are faced with ochre-colored terracotta tiles. The
skyscraper has a glazed facade towards the Land-
wehrkanal.

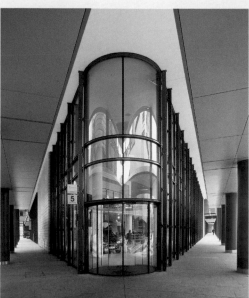

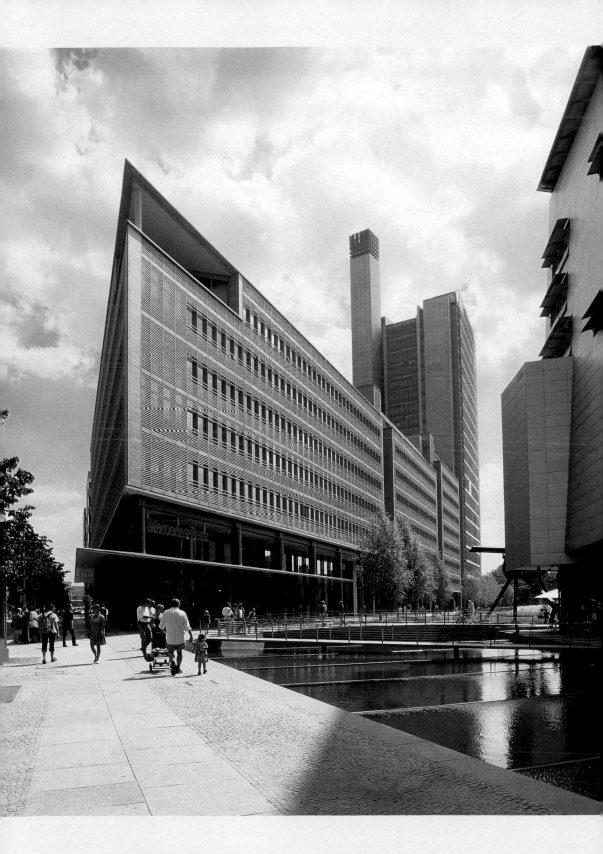

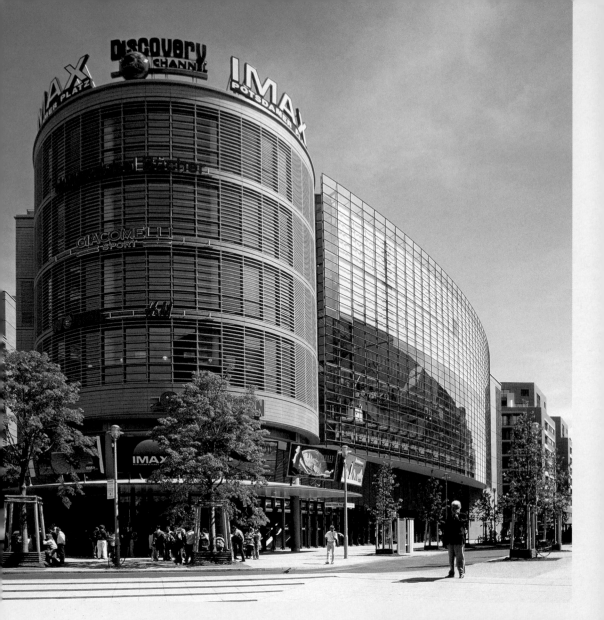

IMAX-Kino (Big Screen Cinema)
(Marlene-Dietrich-Platz/Eichhornstrasse)
Architect: Renzo Piano, Paris/Christoph
Kohlbecker, Gaggenau
1995-98

The extraordinary cinema at Marlene-Dietrich-Platz has a semi-circular building with the cupola of the projection room. The auditorium has a screen measuring 550 square meters. By projecting onto the interior of the cupola the screen can be expanded to 950 square meters.

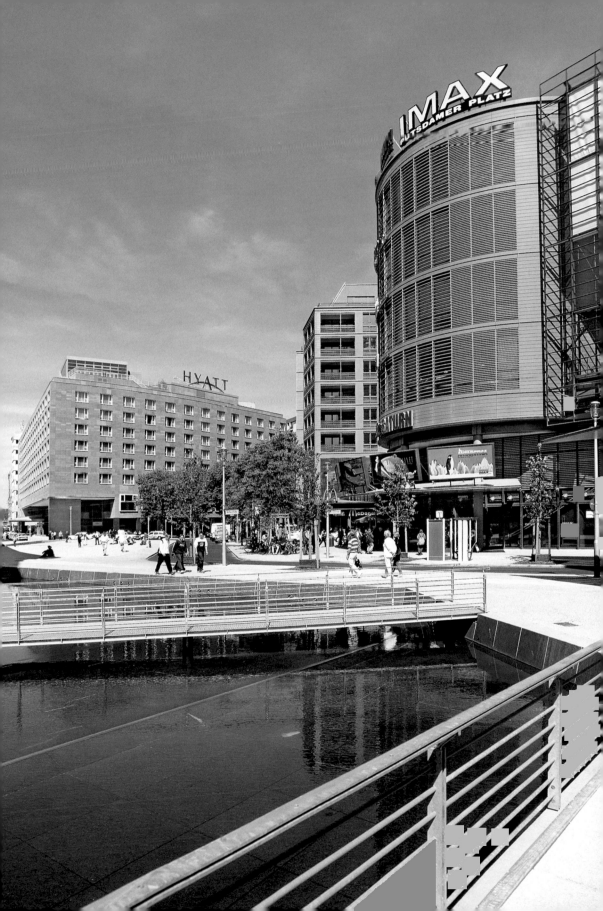

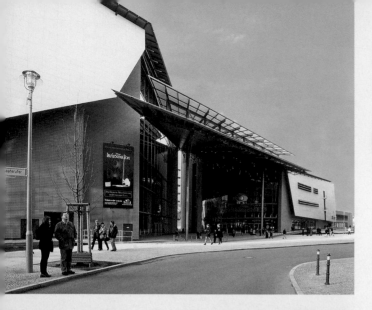

Musical Theater and Casino
(Marlene-Dietrich-Platz)
Architects: Renzo Piano, Paris; Christoph Kohlbecker, Gaggenau
1996-98

The dominant building on Marlene-Dietrich-Platz contains the musical theater and a casino forms the western boundary of the Daimler site and creates a link to the free-standing building of the National Library built by Hans Scharoun. There is only a narrow slit between the two buildings. The architects of the new building designed an asymmetrical ground plan with an elongated form and gleaming silver-grey facades which are modeled after the gold-anodised facing of the New Library. Since 2000 the International Berlin Film Festival is held in the musical theater and nearby Cinemaxx Cinema (Potsdamer Strasse/Voxstrasse, see p. 92).

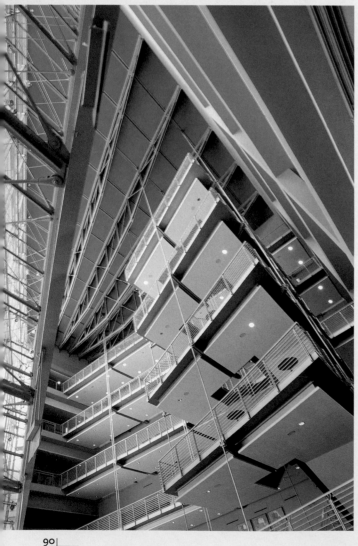

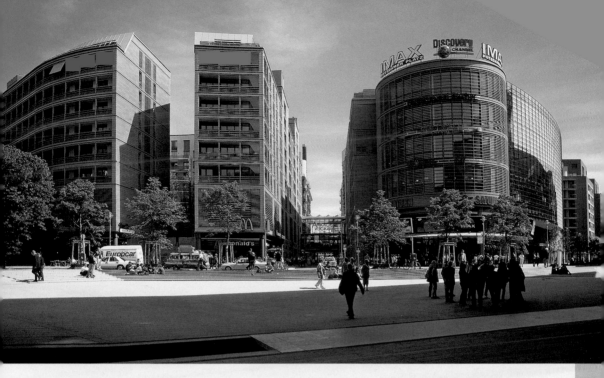

Residential Building

(Alte Potsdamer Strasse/Voxstrasse)
Architects; Ulrike Lauber/Wolfram Wöhr,
Munich

The residential building with an inner
courtyard, red terracotta brick facade and
a staggered roof storey was erected on a
triangular site.

Hotel Grand Hyatt

(Marlene-Dietrich-Platz 2)
Architect: José Rafael Moneo, Madrid
1996-98

The block-like building with a grid-type
perforated facade and red standstone
facing differs from the neighboring buil-
dings. The hotel is part of the American
luxury hotel chain Hyatt.

Cinemaxx Cinema (illustration right)
(Neue Potsdamer Strasse)
Architects: Ulrike Lauber and Wolfram
Wöhr, Munich
1996-98

The building has 19 cinemas on five
storeys and a total capacity of 3,500 visi-
tors. The cinema building faced with
yellow-ocher terracotta bricks fits
perfectly into the new block-style building
area.

Mercedes-Benz AG Head Office
(Potsdamer Strasse 7)
Architect: José Rafael Moneo, Madrid
1995-98

The building faced with yellow sandstone
has a glazed facade on Potsdamer Strasse
which reveals the on the inside covered
atrium. The plot gets smaller towards the
Cultural Forum, giving the west facade
the appearance of a tower.

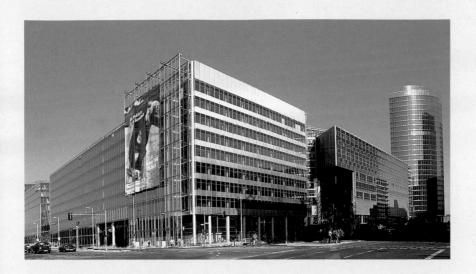

Sony-Areal at the Potsdamer Platz
(Potsdamer Platz/Bellevuestrasse)
Architekten: Helmut Jahn, Murphy/Jahn
Architects, Chicago
1996-2000

The Sony Center is one of the most impressive new districts of Berlin. The big glass buildings are situated around a huge oval square, the Sony Plaza, with cafés, restaurants, stores and movie theatres. Its oval tent-like glass roof is constructed of steel ropes and poles, making it seem to float over the plaza. The roof is a spectacular feat of engineering and is a highlight of Berlin's new architecture.

The twenty-six-storey glass skyscraper at the Potsdamer Platz raises on a half-circled ground-plan by a height of 103 metres. It is the highest building at the Potsdamer Platz.

Remnants of the former luxury hotel Esplanade from 1911 (the breakfast room and the imperial room) are integrated into the new building. The imperial room was hydraulically transposed 75 meters in a spectacular undertaking in 1996. A total of 1,300 tons had to be moved

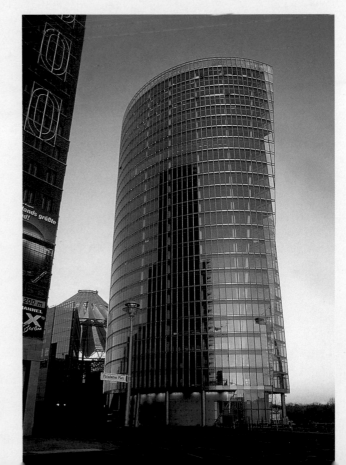

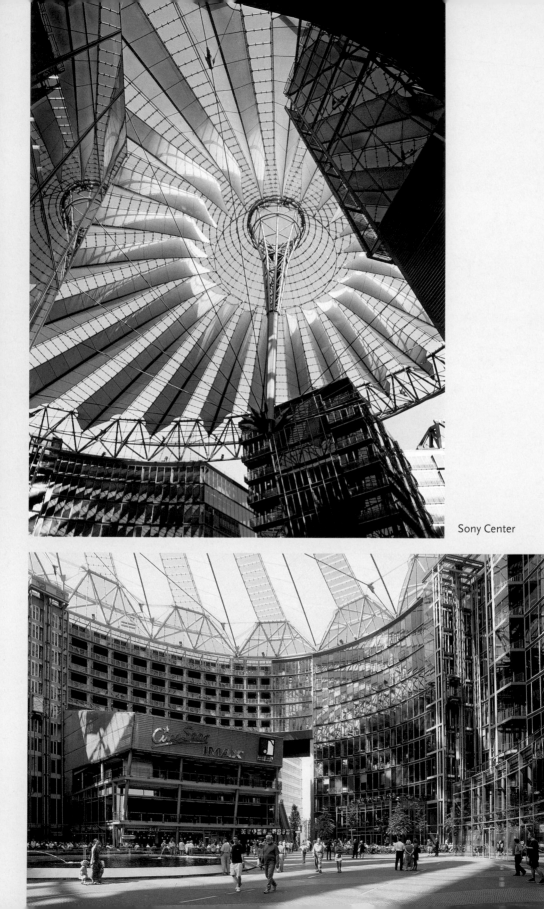

Sony Center

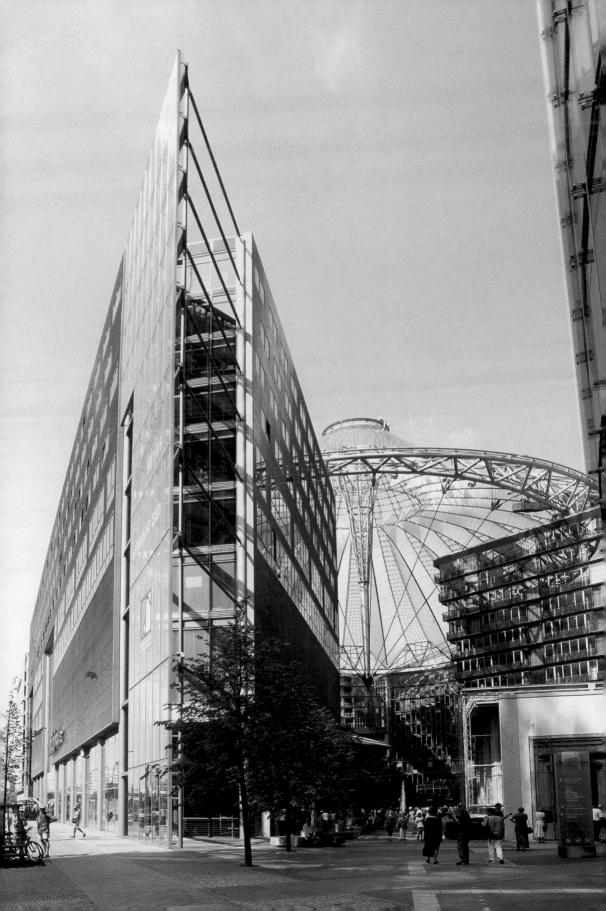

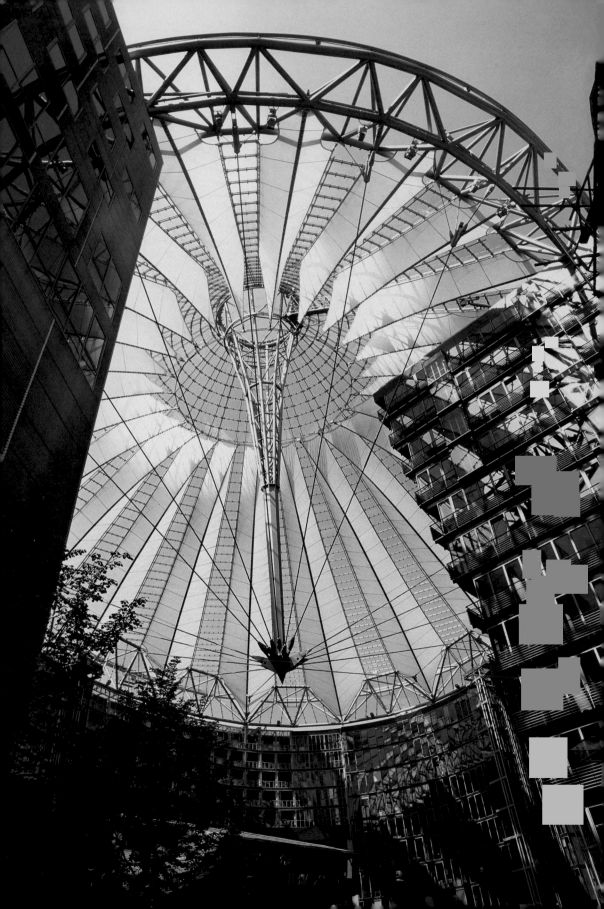

Helmut Jahn

*The German-American Helmut Jahn is
one of the most successful architects of
the United States. He is well-known in
Germany since he designed the Messe
Tower in Frankfurt/ Main (1993). In
Berlin Jahn was responsible for some
remarkable buildings: the building Kur-
fürstendamm 70 (1994, see p. 139), the
Sony Center at Potsdamer Platz (1996-
2000, see p. 93-97), the building Kur-
fürstendamm 119 (1996, see p. 140) and
the Kranzler-Eck (1999-2000, see p. 135).
Born in 1940 in Nurnberg/Germany
Jahn studied in Munich. Since 1967 he is
working in the office of C. F. Murphy
Associates (since 1982 "Murphy/ Jahn").
Helmut Jahn is a master of glass and
steel architecture. His designs are of
outstanding quality and excellently im-
plemented and constructed. Jahn dares
to go again and again to the limit of
framework architecture, as he did at the
Sony Center.*

Above:
Remnants of
the former
luxury hotel
Esplanade
from 1911
are integra-
ted into the
Sony Center.

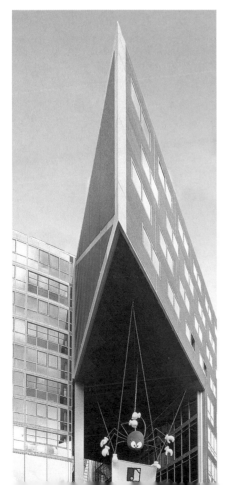

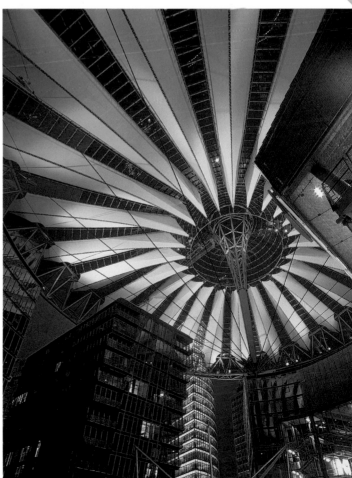

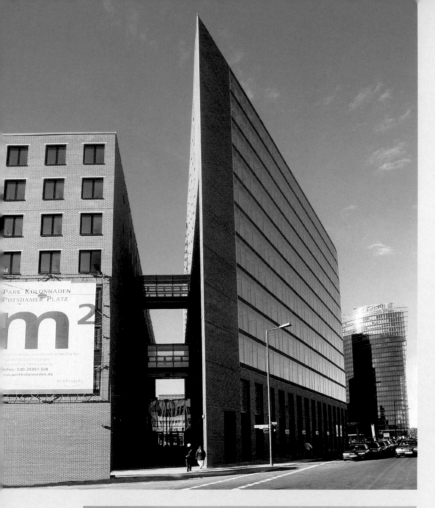

Parc Colonnades
(Potsdamer Platz/Köthener Strasse)
architects: Giorgio Grassi, Milan; Schweger & Partner, Hamburg/Berlin; Diener & Diener/Basle; Jürgen Sawade, Berlin
1996-2001

The complex next to Potsdamer Platz consists of five red brick buildings with flat roofs and H-shaped layouts. On the ground floor an arcade-style passage links the seven- or eight-storey buildings.
The head building by Schweger + Partner at Potsdamer Platz with its rounded corner shape and the glass facade spanning all storeys is the dominate building of the complex.
It is intended to recall the form of the pre-war building, "Haus Vaterland", a famous place of entertainment in its days which was built in 1911/12 by Franz Schwechter. The glass facade reflects the glass-steel architecture of the Sony skyscraper at Potsdamer Platz.

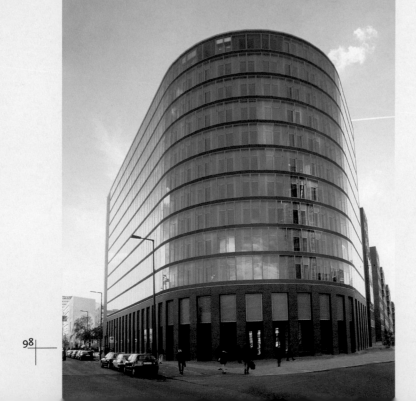

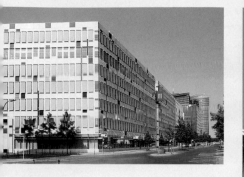

Office Building

(Stresemannstrasse 111)
Architects: Alsop & Strömer,
Hamburg/London
1993-94

The seven-storey office building closes
the historic block structure directly oppo-
site the Martin Gropius Building near
Potsdamer Platz. The facades with the
different types of blue glass, differently
treated metal sheetings and polished sur-
faces contrast with the other new buil-
dings. The design of the sharp corners is
fascinating.

Residential and shop building

(Askanischer Platz 4)
Architect: HPP Hentrich-Petschnigg &
Partner KG, Berlin
1996-97

The well-proportioned eight-storey buil-
ding occupies a corner site.

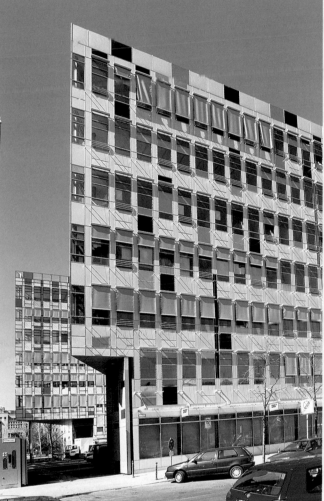

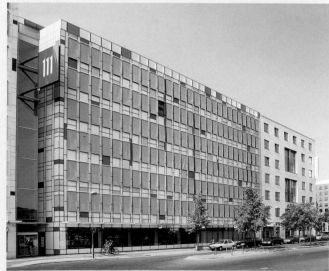

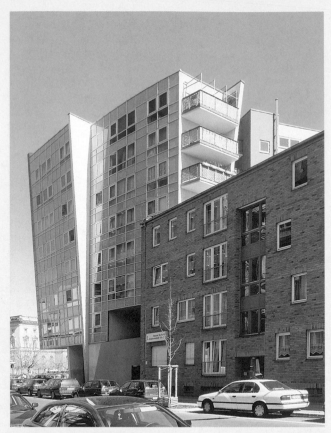

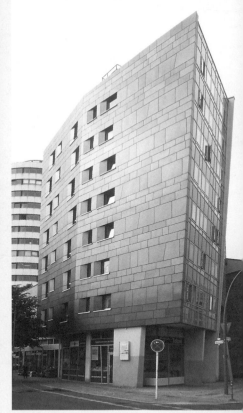

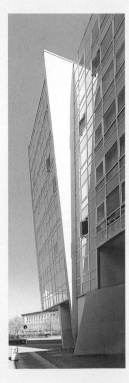

Residential Building
(Stresemannstrasse)
Architect: Zaha Hadid
1993-94

The Anglo-Iranian architect Zaha Hadid, a student of the London Architectural Association School, is well-know for her extraordinary designs with slanted and angled wall and window constructions. Like Libeskind (Jewish Museum) she forms the buildings like a big sculpture. That is what she also did with the acute-angled corner building Stresemannstrasse/Dessauer Strasse. She designed oblique wall constructions which were shifted towards each other. The eight-storey building is faced with bronze, which results in changing light reflexions.

Foundation "Topography of Terror"
(Stresemannstrasse 110)
Architect: Peter Zumthor, Haldenstein
1997-2004

The Swiss architect Peter Zumthor (born 1943 in Basel) designed the new administrative, documentation and exhibition center of the foundation "Topography of Terror" next to the Martin-Gropius Building. Between 1933 and 1945 the National Socialist command centers were located between Stresemann-, former Prinz-Albrecht-, now Niederkirchner-, Wilhelm- and Anhalter Strasse. The buildings were demolished in World War II and levelled after 1950. Only the so called kitchen cellars (cellars of the Gestapo headquarters in the Prince Albrecht Hotel) are still extant. They were later covered by the new 120 meter long and 20 meter high building with its closely spaced concrete beams.

(fotomontage)

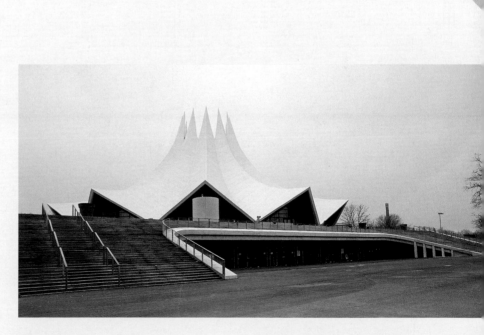

Tempodrom
(Park, former Anhalter Bahnhof/ Askanischer Platz)
Architects: "gmp" (von Gerkan, Marg & Partner), Hamburg
2001/2002

On the site of the former Anhalter Bahnhof (railway station) which was demolished in World War II the gmp office designed a tent-like building for alternative music and theater with two arenas for 3,700 and 500 persons.

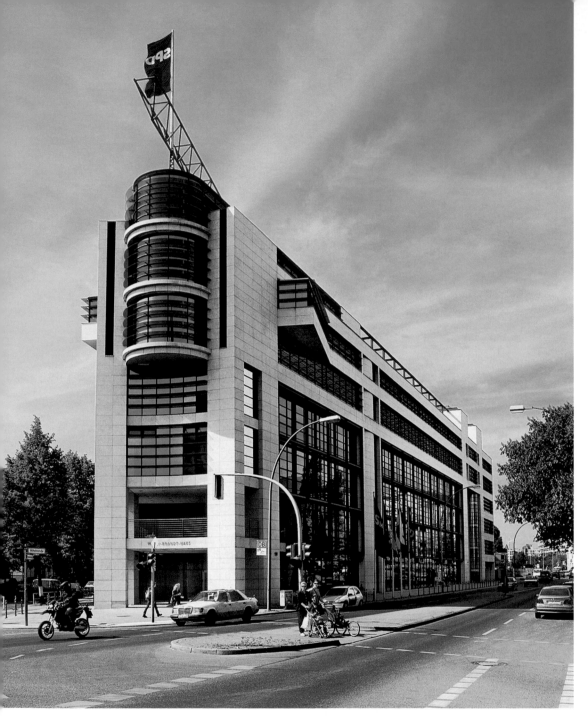

Willy Brandt House
(SPD headquarters)
(Wilhelmstrasse 140-141, Stresemann-
strasse 28)
Architect: Helge Bofinger & Partner,
Wiesbaden/Berlin
1993-96

The impressive seven-storey building,
which had already been planned after
1983, was not carried out until 1993-96
at a prominent location within the city –
at the corner of Stresemannstrasse and
Wilhelmstrasse. The triangular plan buil-
ding is constructed around an atrium.

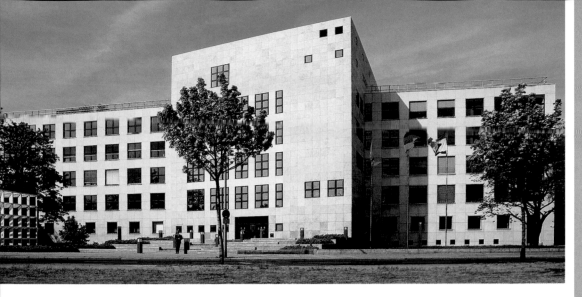

Family Court Tempelhof/Kreuzberg
(Hallesches Ufer 62-64)
Architect: Oswald Mathias Ungers &
Partner GmbH, Berlin
1993-95

The new family court building is an ex-
tension of the old building on Möckern-
strasse and a typical design by the fa-
mous architect Ungers from Cologne.
He uses the motif square which can be
found in all variations and details.
The windows therefore have square win-
dow panes. The dominant main building
in the middle of the facade to the Halle-
sches Ufer consists of a cubic block.
The geometric sculpture in front of the
building is modelled after the shape of
the building. It was designed by the
American artist Sol Le Witt.

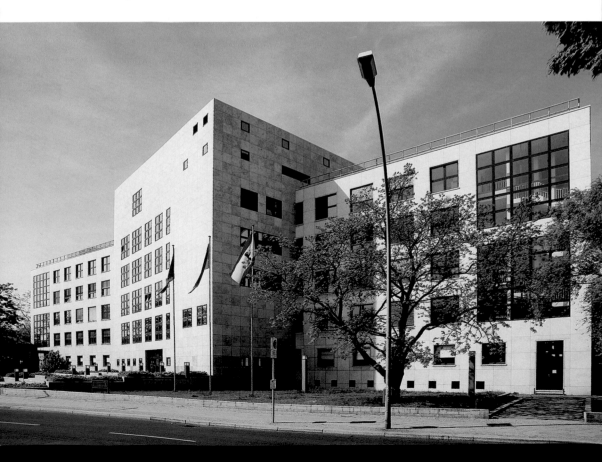

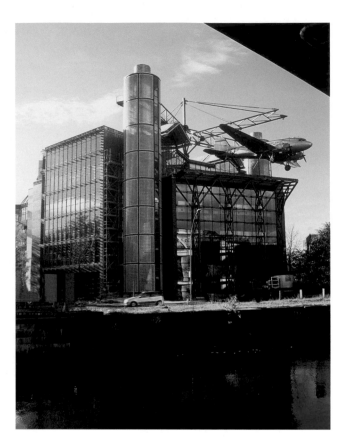

**Deutsches Technikmuseum Berlin/
German Museum of Technology**
(Trebbiner Strasse 10-15; Tempelhofer
Ufer)
Architects: Ulrich Wolff, Helge Pitz,
Berlin
1995-2001

One of the planes used during the Berlin
Airlift in 1948/49 is poised in flight in
front of the entrance to the new building.
After the Deutsche Museum in Munich
the German Technology Museum is the
biggest and most important of its kind in
Germany.
The new building, which is part of an
ensemble with the old building and the
Anhalter freight station, is one of the
city`s prominent museum projects. Like
the Technology Museum itself the buil-
ding is full of technical innovations.

VG Office Building
(Tempelhofer Ufer 30)
Architect: Joachim Ganz, Berlin
1997-99

The office building spans across the urban
railway lines between Möckernbrücke and
Gleisdreieck. The main facade looks to
the atrium at the Landwehrkanal.

Jewish Museum

(Lindenstraße 14, Berlin-Kreuzberg)
Architect: Daniel Libeskind
1992-99

Daniel Libeskind was chosen from among 165 competitors to design the Jewish Museum in the area next to the Berlin Museum. After a lengthy delay due to financial problems the ground breaking ceremony finally took place on November 9, 1992. The interior has been finished since February 1999. The museum, archive and library will be open to the public beginning in September 2001.

The building is a large walk-in sculpture, a piece of symbolic architecture. The building's ground plan has the shape of a bolt of lightening whose irrational character is emphasized by the silver shining zinc covering. The zigzag shaped building with its ten sharp bends has a dynamic and aggressive nature that is expressed in the tears- i.e. window slits- and the lines of intersection which cut into the scaled sheet metal exterior. Libeskind in-

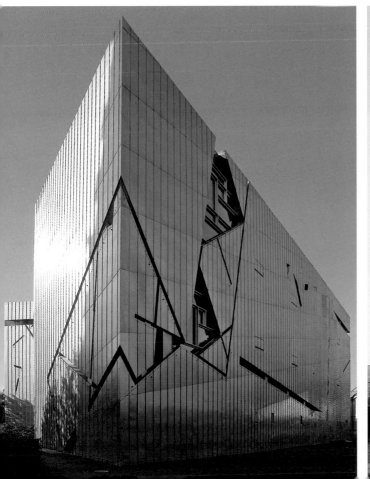

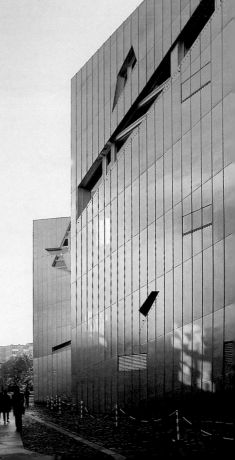

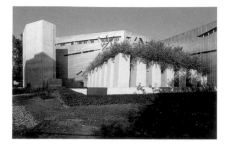

interpreted as three "paths of fate." One path leads to the dead end of the "Holocaust tower," which is located behind a heavy iron door. It consists of a cold and dark twenty-meter high dungeon and is similar to the tombs of Egyptian temple graves. The second path leads to the "E.T.A. Hoffmann Garden," where 49 tree covered concrete steles standing on a sloped ground plate symbolize the flight into exile. Visitors become aware that the steles and the floor are slanted because the entire surroundings suddenly turn crooked and seem to become askew. The third path, (that of life and of a German-Jewish symbiosis) leads over a splendid flight of stairs to all three exhibition floors. Here beams and cross bars appear to crash down on the visitors, although Libeskind asserts that they all have a structural function

Inside of the building you repeatedly encounter empty rooms which do not serve a purpose and are divided among different floors. Initially, these so-called "voids" should have been inscribed with the names of murdered Jews similar to a burial chamber. However, this would have been all too obvious and would have given the voids a clear function of commemoration. That would have damaged the

itially planned to even have the outer walls of the back part of the building stand diagonally. Due to the high costs this would have involved, it was not carried out.

The interior area behind the facades covers ten thousand square meters on five stories. Neither the exterior nor the interior remind one of a museum. Rather, the rooms are full of corners and always offer new viewpoints. There are big halls, small rooms and hallways.

The labyrinth-like building is meant to revive history and make visitors aware of the losses incurred by history. In its resemblance to an apocalyptic sign, the building can also be interpreted as a broken and stretched star of David. Within the building are three axes symbolizing the history of Judaism in Berlin. They are

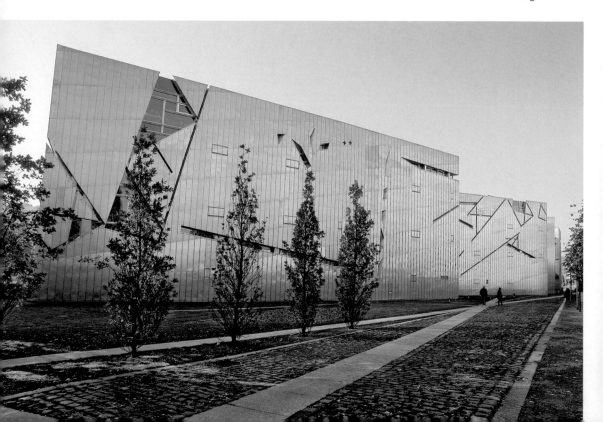

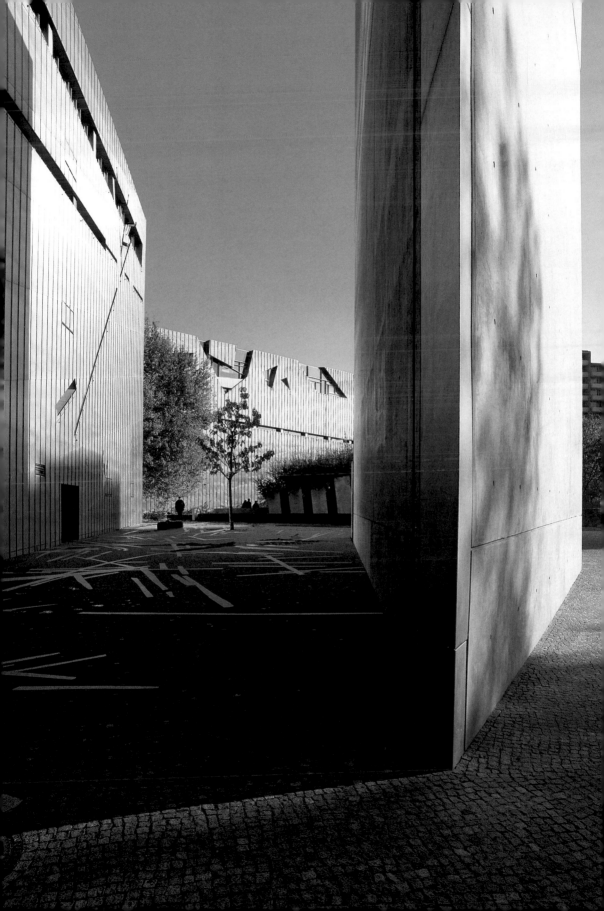

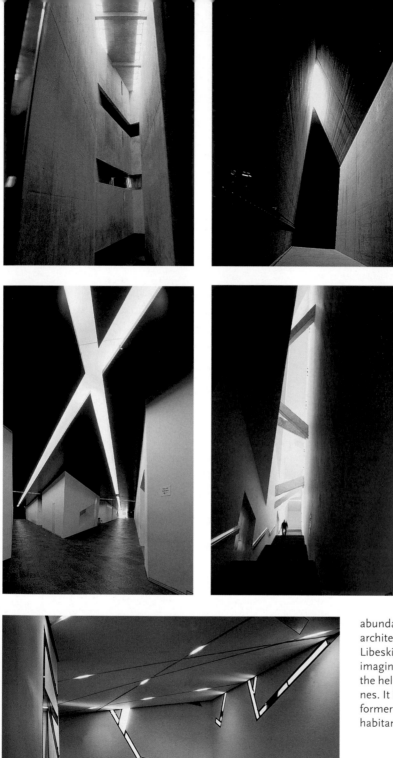

abundance of associations linked to the architecture.

Libeskind boasts of having created an imaginary piece of city architecture with the help of a network of intersecting lines. It is therefore meant to evoke the former residential areas of the Jewish inhabitants of Berlin.

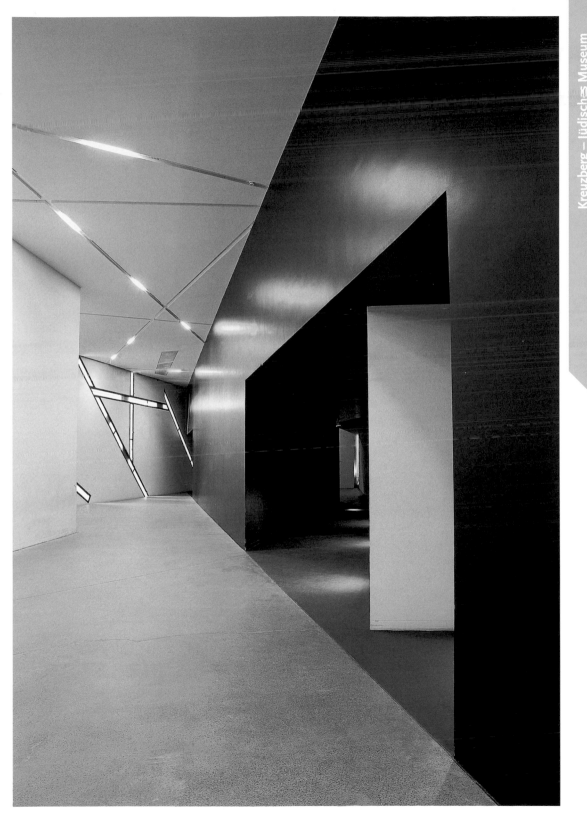

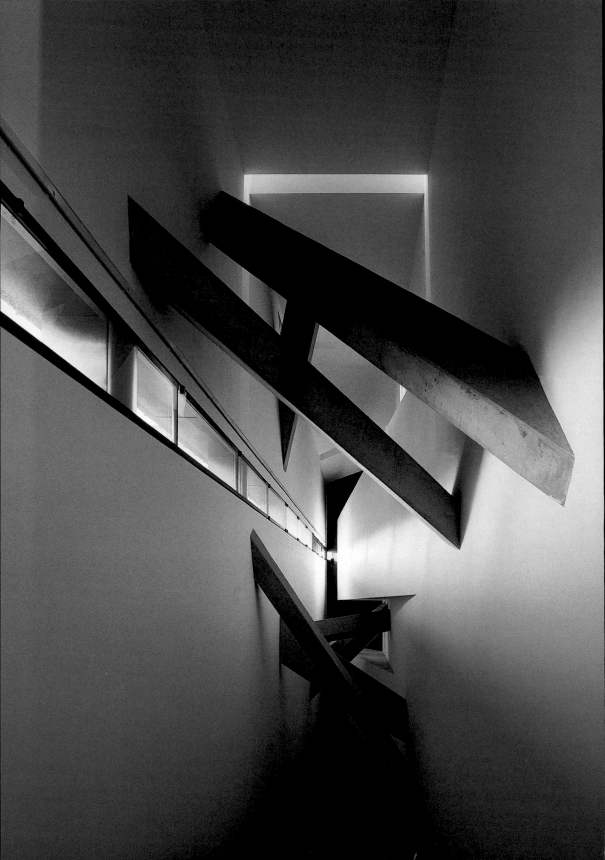

Daniel Libeskind

Born in Lodz, Poland, in 1946, Libeskind studied art and music in Tel Aviv, and architecture in New York and in Essex, UK. His parents emigrated to Israel in 1957, and to the U.S. in 1960. In 1989 he moved to Berlin.
The Jewish Museum in Berlin was his first big historical monument which was at the same time a masterpiece of the outgoing 20th century. More resolute than his colleagues, he considers designing and building to be an artistic act. He strives for a maximum amount of autonomy in architecture, which he links to history, literature and philosophy.

p. 110: Jüdisches Museum, Treppenhaus

Extension of the Federal Government Printers
(Kommandantenstrasse 15)
architects: BHHS & Partner (Bayerer, Hanson, Heidenreich, Marinez, Schuster), Berlin
1993-97

The five-storey new building is situated along the Kommandantenstrasse where the former Berlin Wall stood until 1990. Behind the big glass facade you can see technical apparatus and metal pipes. Fascinating is the prismatic-triangel main-entrance-block.

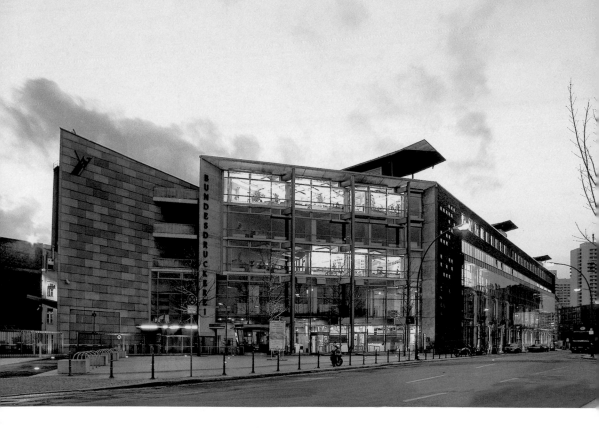

Office and Residential Complex Spittelmarkt
(Spittelmarkt, Beuthstrasse, Seydelstrasse)
Architects: Zaha Hadid (initial design), HPP Hentrich-Petschnigg & Partner, HDS & Gallagher, Dieter W. Schneider & Partner
1996-98

The most striking building at Spittelmarket is the 22-storey tower. Due to its large glass surfaces and especially the two recessed floors in the middle, this building forms a pleasant contrast to the neighboring highrises from the GDR era along Leipziger Strasse. The attempt to rhythmically continue the high-rise architecture of Leipziger Street and at the same time to combine it with a new concept for construction along the margins of city blocks is remarkable.

Jannowitz Center
(Brückenstrasse)
Architects: HPP Hentrich-Petschnigg & Partner, Düsseldorf
1993-97

The office block is a restless agglomeration located directly at the River Spree vis-à-vis the Jannowitzbrücke train station serves as a bridgehead. The building is characterized by new materials - glass, concrete and steel - and modern elements - hanging roofs, wall panes, tilted walls and glass – as well as ornamental motifs.

Embassy of Brazil

(Wallstrasse 59)
architects: Pysall, Stahrenberg, Berlin
1998-2000

The new building next to the river Spree close to the Märkisches Museum is part of a 22 meters high blocktype office complex.

Commercial Premises

(Axel-Springer-Strasse 50)
architects: Rupert Ahlborn & Partner, Berlin
1994-96

The extension building has a semi-circular tower which emerges from the street-facing building and forms the facade.

Commercial Premises

(Axel-Springer-Strasse 52)
architects: Krug, München
1994-95

The facade is structured by a glass and a wall facing structure.

Axel-Springer-Strasse 50 (left) and 52 (right), Jannowitz Center (below)

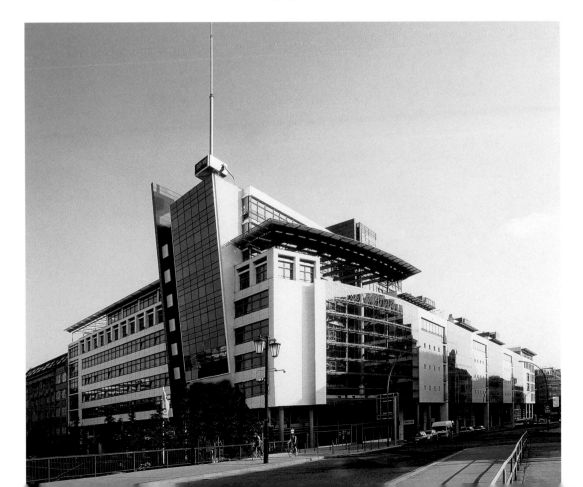

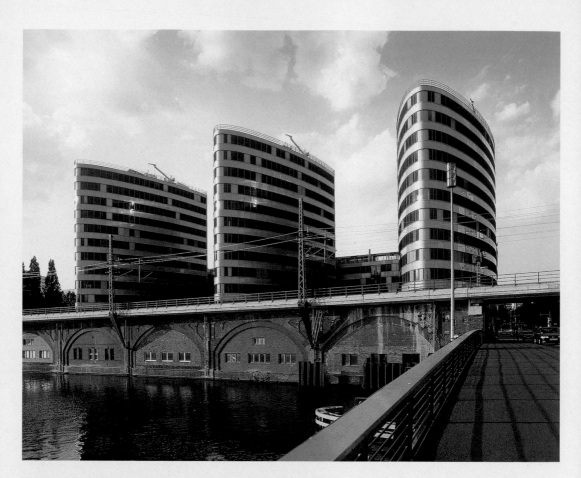

Trias Office and Shopping Building
(Holzmarktstrasse 15-18)
Architects: Beringer & Wawrik (Lucia Beringer and Günther Wawrik), Munich 1994-96

The office and shopping building "Trias" next to S-Bahnhof Jannowitzbrücke (urban railway station) dominates the silhouette of the northern bank of the River Spree. The building is therefore one of the best known in the eastern part of Berlin. The distinctive 13-storey bow-shaped tower buildings are faced to the river. The towers are connected by a six-storey block along the street.

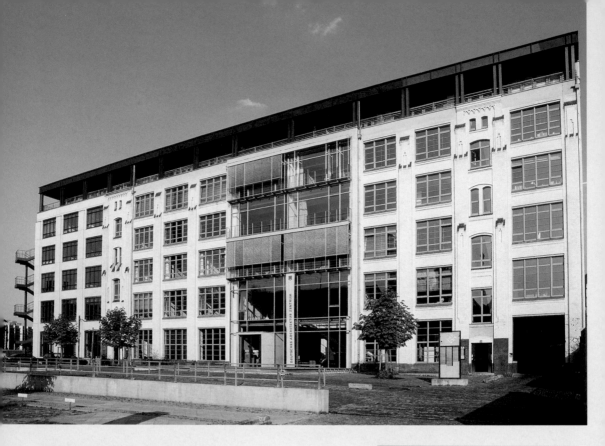

**Deutsches Architektur Zentrum/
German Architecture Center (DAZ)**
(Köpenicker Strasse 48-49)
Architects: Claus Anderhalten, Berlin;
Assmann, Salomon & Scheidt
1994-96

Since 1995 the German Architecture Cen-
ter (Deutsches Architektur Zentrum/
DAZ) and the National Association of
German Architects (Bund Deutscher
Architekten/BDA) are located in the
former Maschinenbaufabrik Stock, a brick
building dating from 1903. The building
is a good example for the combination of
historical (brick) and modern (glass steel
construction) architecture.

Headquarters of the Berlin Water Works
(headquarters of Berlin Wasser Holding AG)
(Stralauer Strasse 32-41/Rolandufer)
Architects: Buildings I and II: Joachim
Ganz, Berlin; Building III: Christoph Lang-
hof along with Thomas Hänni and Alfons
Wening
1997-2000

House III was constructed in sharp contrast
to the neighboring Baroque building, the
Palais Schwerin at Molkenmarkt. It is situa-
ted directly next to the palace and has the
same roof and floor heights and window
sizes. In terms of building material and
architectural expression, the new structure
is totally different. The five-storey steel con-
crete building at Molkenmarkt is covered

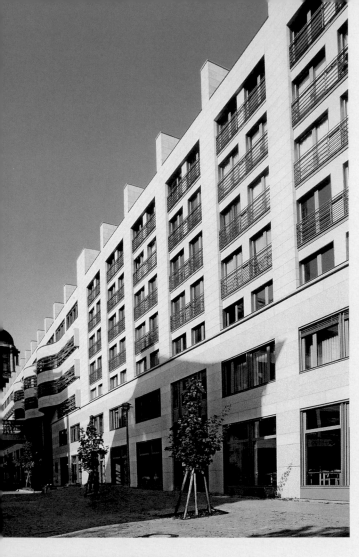

with titanium zinc rhomboids. Due to the round shape and the uniformity of material, the roof and the walls unite to form a single area, in which the windows are inserted. The facade is composed of broken, prism-like artificial stones which have the color of granite and are based on the styles of Expressionism and Cubism, and perhaps even on the anthroposophical architecture of Rudolf Steiner. The office blocks I and II were designed by Joachim Ganz according to a historical building on Rolandufer. The three-storey high entrance of House I is shaped like a set of three waves. This is an allusion to the buildings' usage by water companies. The three rows of windows from the third to the fifth floor have wave-shaped window panes.

Quartier at Hackescher Markt

(Rosenthaler Strasse, Hackescher Markt, An der Spandauer Brücke, Dircksenstrasse) Architekten: Götz Bellmann & Walter Böhm, Berlin (overall concept and individual buildings); Martina Guddat, Annette Bellmann, Sabine Kattusch, Berlin; Marc Kocher, Zürich; Neuer + Jasinski, Berlin (individual buildings) 1996-98

New block like buildings can be found along the streets at Hackesche Markt vis-à-vis the Hackesche Höfe. The quarter is modeled after the surrounding traditional architecture, especially the famous art nouveau facade of the old Hackesche Höfe and other buildings from the time around 1900. This finds expression in the similar proportioning and arrangement of the stories and eaves, the maintenance of the historical dimensions of the individual plots of land and the steeply tilted roofs above two stories. The diverse appearance of the building as a whole is also due to the impression that it successively was built over several centuries. This appearance was created by giving the floors, eaves and roofs different heights and using different elements, materials and colors for the facades. Three inner courtyards belong to the quarter, of which 50 % is used for residential purposes.

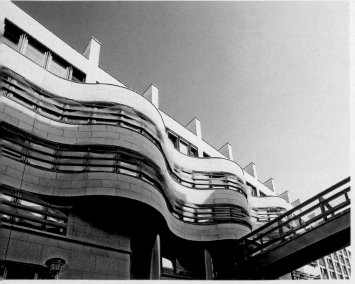

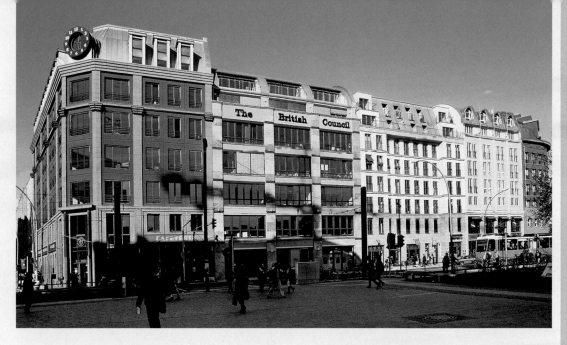

Top: Quartier at Hackescher Markt

Residential and Office Building with a restaurant (Auguststrasse 1,
ill. right)
Architect: Horst Basedahl, Buxdehude, 1998-99

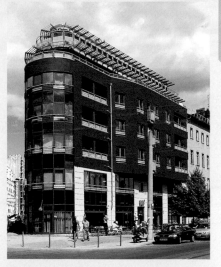

Office, Commercial and Residential Building (Hackescher Markt 2-3,
ill. below left)
architects: Grüntuch and Ernst Architekten, Berlin, 1999-2000

Filmförderungsanstalt (Grosse Präsidentenstrasse 9,
ill. below right)
architects: Frank Hüpperling/Stephan Vieweger, Berlin
1999-2000

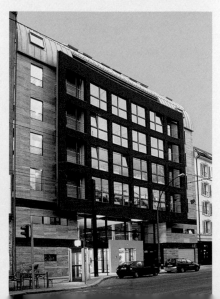

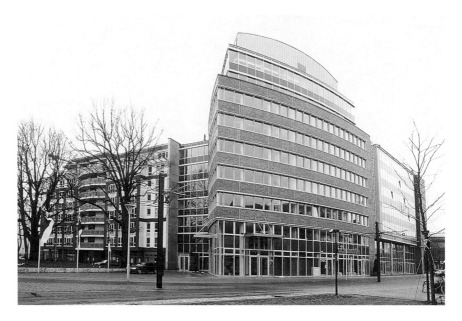

Building complex at the Museum Island
(Burgstrasse 21-30)
Architects: Steffen Lehmann Architekten,
Berlin
1992-99

The complex of four buildings has been
erected to the south of the railway lines.
The building used by the Versorgungsan-
stalt Deutscher Bühnen is constructed on
a triangular plan with undulating facades.

Bank of German Charity Organisations
(Oranienburger Strasse 13-14)
Architekts: Dissing & Weiting, Kopenhagen
1996-97

The Bank of German Charity Organisa-
tions (Bank für Sozialwirtschaft) erected
its new building at the pre-war site.

**Wohnhäuser am Bahnhof Hackescher
Markt** (Neue Promenade)
Architects: Reymer & Partner, Berlin
1997-98

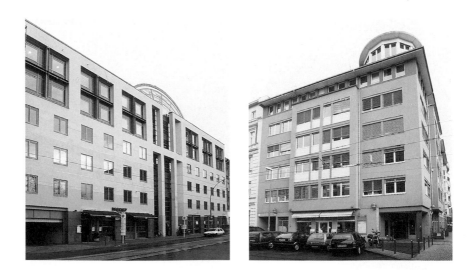

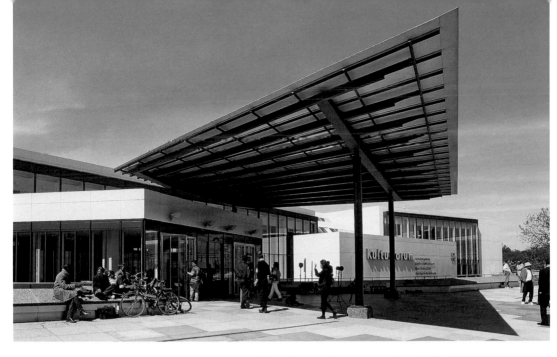

Picture Gallery

(Matthäikirchplatz 8)
Architects: Hilmer & Sattler and
R. Albrecht, Berlin/Munich
1992-98

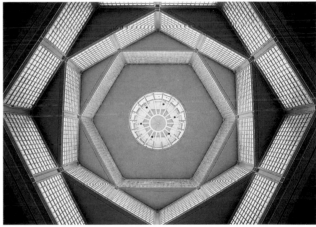

The new building for the international
important collection of paintings was
erected between 1992 and 1998 accor-
ding to plans by Hilmer & Sattler, who
had already been given the task to finish
the culture forum in 1988. This happened
after the arts and crafts museum built by
Rolf Gutbrod between 1978 and 1985 had
been heavily criticized and the shells of
the unfinished art library and of the
"Piazetta" which were already begun by
Gutbrod were supposed to be finished
by other architects. In contrast to the
philharmonic and the national library
(both by Hans Scharoun), the picture
gallery's exterior emphasizes calmness.
This is in sharp contrast to the urban
development plans of the 1950s and
1960s, when the emphasis was on
spacing buildings far from each other,
a plan which was, for example, realized
in the cultural forum in West Berlin. With
the new construction of the picture gal-
lery the historical concept of the enclosed
town district was again revived as expres-
sed by block-like buildings along the
streets. The facades are covered by gray
stones bearing diamond-shaped reliefs

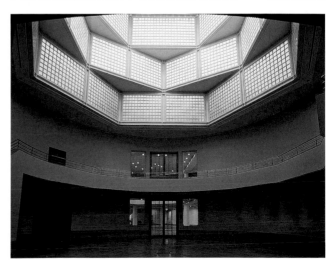

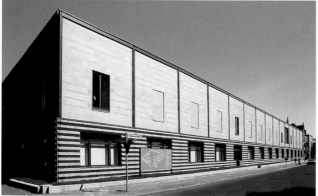

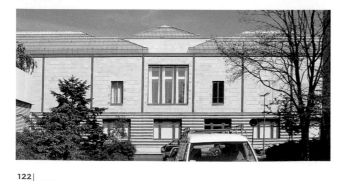

as well as by large sand stone plates with wide joints.

Their natural color differences are brought to bear in a convincing manner. The gallery is linked to the entrance hall by a round vestibule with a cupola made out of glass bricks which have the shape of inserted hexagons. The picture gallery must share the entrance hall with the other buildings of the culture forum. A spacious three-aisled hall (with the sculpture "5 – 7 – 9" by Walter de Maria) is connected to it. From here one can access the halls and galleries.

Konrad-Adenauer-Stiftung

(Tiergartenstrasse 35)
Architects: Thomas van den Valentyn
and Anja Zeisner, Cologne
1996-98

The conference and office building of the Konrad Adenauer Foundation is located only a few meters away from the national headquarters of the CDU. The cube-shaped building made out of sandstone stands at the northwestern corner of the diplomatic quarter. It has a row of windows for the offices in the upper floors. There is also a large open roof over the entrance. The building will later be extended by an office building parallel to Klingelhöferstraße.

Representative Office of the State of Bremen

(Hiroshimastrasse/Reichspietschufer)
Architects: Hilde Léon and Konrad
Wohlhage, Berlin
1998-99

The first state representative office to be completed was the one of Bremen. Particularly striking are the red coat of paint and the separation into two buildings: a four-storey administrative and office building and a slender seven-storey tower for the guest apartments.

Above:
Konrad-Adenauer-Stiftung

Below:
Representative Office of the State of Bremen

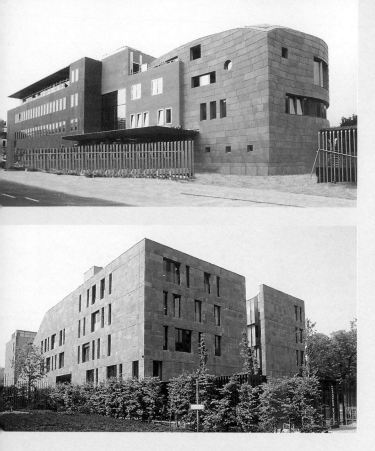

Austrian Embassy

(Tiergartenstrasse 12-14/Stauffenberg-strasse 1-3)
Architect: Hans Hollein, Vienna
1999-2000

The Austrian embassy which stands on the corner plot of the diplomatic quarter near its old location is one of Berlin's spectacular embassy buildings.
The extravagant building complex consists of three overlapping buildings, which are different from each other in terms of architecture and function: The consulate is located on Stauffenberg-strasse and can be entered through an entrance which has a hanging roof.
The part of the building located on Tiergartenstraße which is covered with copper plates forms a contrast to this rather common building. It stands out especially due to its curved roof (modeled after the Rudolf Steiner's Dornach buildings and Le Corbusier's Notre-Dame-du-Haut in Ronchamp) and the horizontal bands of windows. Its oval shaped central hall is used for receptions and festivities. The residence of the ambassador is located in the back part of the complex which was built according to the modernist style of the 1920s.

Indian Embassy (Tiergartenstraße 16-17)
Architect: Léon Wohlhage Wernik, Berlin, 1999-2001

The slender five-storey building has a round atrium near Tiergartenstraße and a courtyard in the back that contains a cylinder housing the ambassador's offices. In the Southern part of the courtyard there is a large exterior flight of stairs leading to the roof garden. Indian sandstone was used for the facade which is divided by tears, openings and windows.

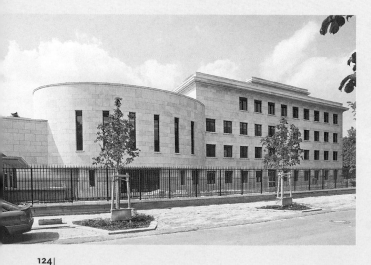

Japanese Embassy

(Tiergartenstrasse 24-25)
Architects: new building : Ryohel Amemiya, Tokyo; with HPP, Berlin
1998-2000

The Japanese embassy from 1940 (according to plans by Ludwig Moshamer) which had not been used after being damaged during the war, was almost completely torn down and rebuilt in 1988. The expanded new building is modeled after the old one and uses some of its material. Only the elliptical building for the visa department on Hiroshimastraße has a modern appearance.

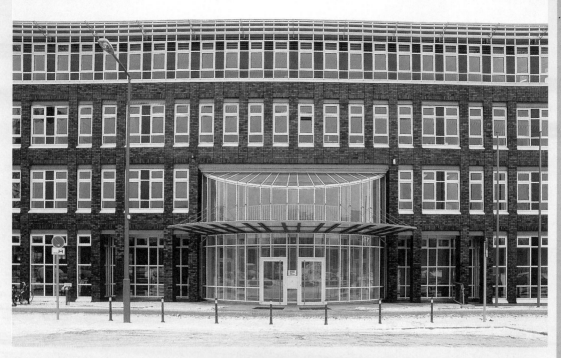

Seminar Center of the Friedrich Ebert Foundation

(Hiroshimastrasse 17-25)
Architects: Fritz Novotny, Arthur Mähner; Volkhard Weber
1997-99

A round shaped conference and exhibition area for 250 to 500 people with a glass facade in its southern part is the core piece of the complex made out of dark bricks.

Representative Office of the State of Baden-Württemberg

(Tiergartenstrasse 15)
Architects: Dietrich Bangert, Berlin
1998-2000

This compact, rectangular building conforms to the eaves height of 16 meters valid for the Tiergarten district. The prominent entrance area beneath the top floor cuts into the building like a wedge.

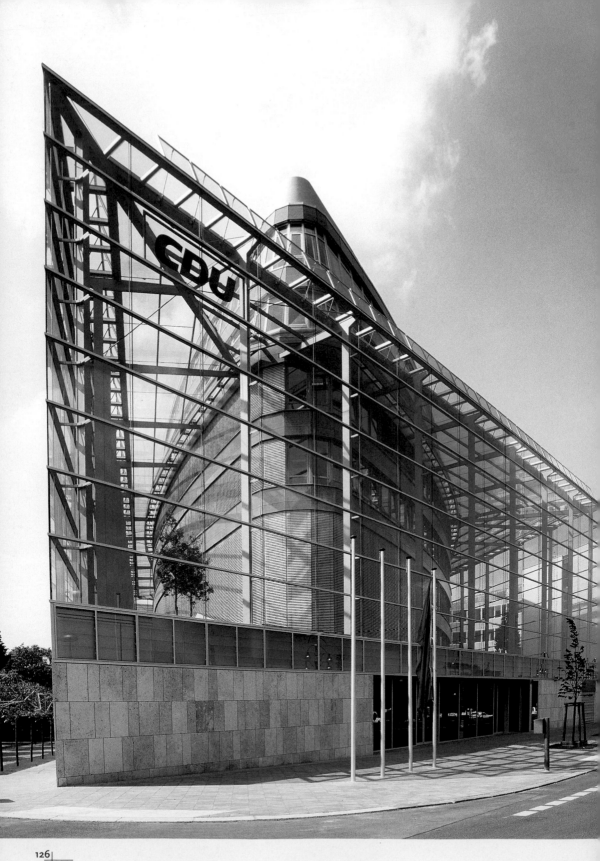

National Headquarters of the CDU
(Klingelhöferstrasse/Cornelius-
strasse)
Architects: Petzinka, Pink and Part-
ner, Düsseldorf
1998-2000

The national headquarters of the
CDU is located in the most promi-
nent place of the Tiergarten Triangle.
It consists of a glass hall inside of
which there is a solid building erec-
ted on a lens-like layout. The inner
building has the shape of a turned
over hull and protrudes above the
glass building which is used as a
winter garden on two floors.
150 people work in this building.

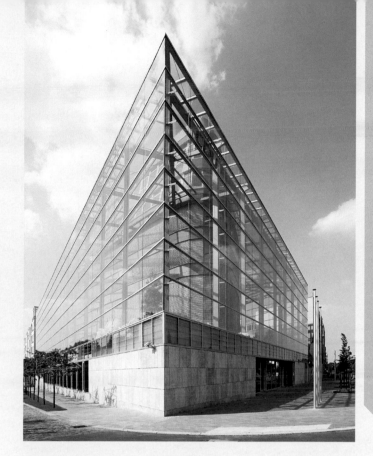

Below: Mexican Embassy (see p. 128)

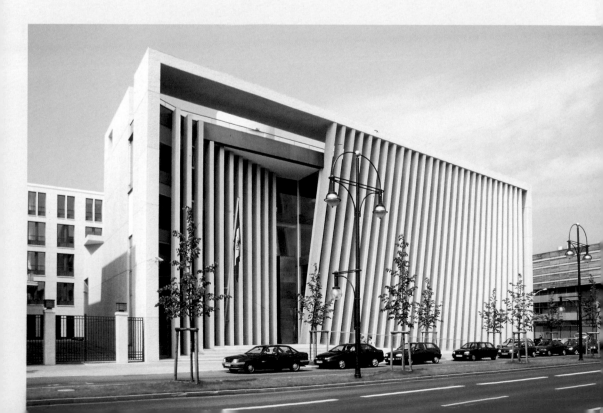

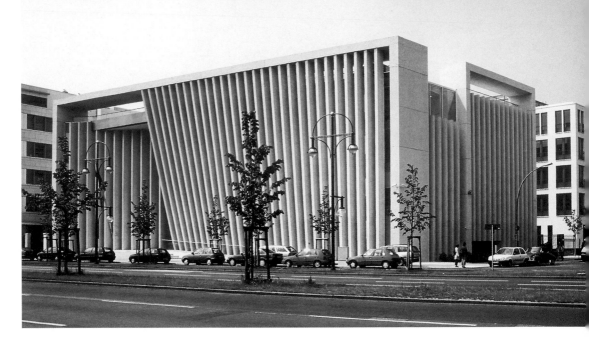

Mexican Embassy

(Klingelhöferstrasse 3, Rauchstrasse 27)
Architects: Teodore González de León,
J. Francisco Serrano, Mexico City
1999-2000

The 18 meter high facade is marked by two tilted lamella walls, which both conceal the entrance and accentuate it.

On closer inspection the composition of the lamella becomes evident and one sees that it is made of concrete with pieces of cut-out marble. Between the lamellas one can look into the interior of the buil-ding through a glass wall. From a distance the thin concrete poles appear to shift towards each other.

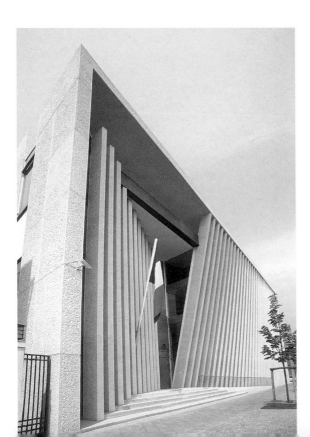

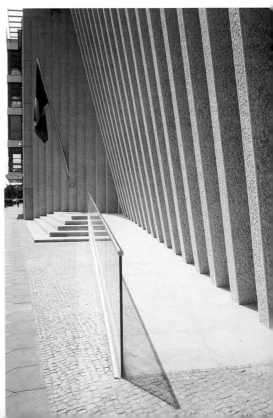

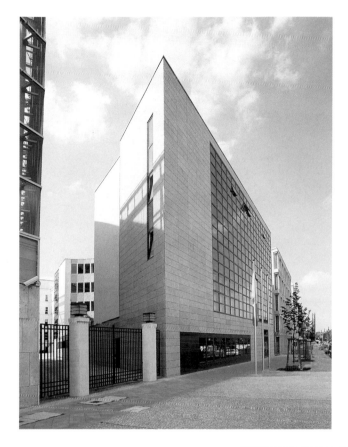

Tiergarten Triangle

The Tiergarten Triangle (Klingenhöferstrasse/Corneliusstrasse/ Stülerstrasse/ Rauchstrasse) is located between the western part of the city and the diplomatic quarter. It was built by eleven architects in the period between 1998 and 2000 around a central park with a border for embassies, apartments, associations and business premises. The building has a height of 18 meters. Its height is only exceeded minimally by the lens-like inner building of the national headquarters of the CDU.

Commercial Buildings
(Klingelhöferstrasse)
Architects: S. M. Oreyzi, Köln; Petzinka, Pink and Partner, Düsseldorf; Gesine Weinmiller, Berlin; Moore Ruble Yudell, Santa Monica; Büttner-Neumann-Braun, Berlin
1998-2000

The four houses located along Klingelhöferstraße between the party headquarters of the CDU and the Mexican embassy were designed by four different architecture firms. The eaves height of 18 meters was uniformly maintained throughout. Since different building materials were used (panes and sandstone facings) the buildings form a nice contrast. The solutions for the corners are particularly interesting as they are composed of acute and obtuse angles.

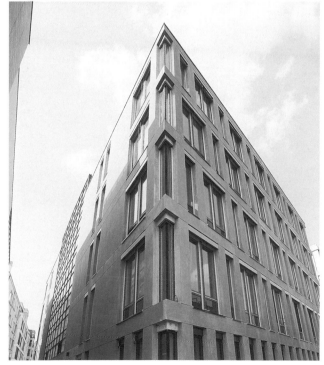

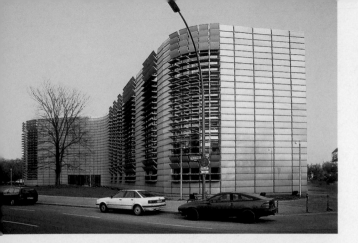

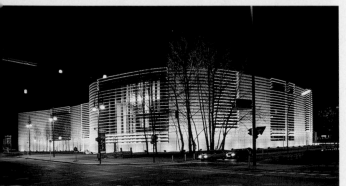

Nordic Embassies
(Rauchstrasse 1)
Architects: Alfred Berger and Tiina Parkki-nen, Vienna (overall design and jointly used building); Nielsen, Nielsen & Nielsen, Arhus (Danish Embassy); VIIVA Arkkitehtuuri Oy, Helsinki (Finnish Embassy); Pälmar Kristmundson, Reykjavik (Icelandic Embassy); SnØhetta as, Oslo (Norwegian Embassy); Wingårdh Arkitektkontor AB, Göteborg (Swedish Embassy)

The Nordic Embassies are among the most interesting new buildings in Berlin. Not only is the extraordinary architecture remarkable but also the fact that the five Scandinavian countries Denmark, Finland, Iceland, Norway, and Sweden are sharing a single complex. They chose the Northern tip of the Tiergarten triangle as the location for their embassies. After a Europe-wide competition with more than 200 submitted drafts, the design for the buildings was created by the Austrian-Finnish office Berger and Parkinnen. The enclosed the complex along Klingelhöfer- and Stülerstrasse with a 16 meter high lamella band made of copper. The positions of the embassies to each other almost correspond to their geographical location: in the southwest the Danish, in the west the small Icelandic, in the northwest the Norwegian, in the northeast the Swedish and in the southeast the Finnish embassy. The building, which is open to the public, serves as a reception, lecturing and exhibition center. The building is given a pleasant exterior by the wood-filled concrete

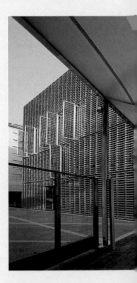

framework that has glass slits cut into it. The five consulate buildings were constructed by architects from the respective countries. Building materials used are typical of the home countries. A typical example is the granite plate from Norway which has a

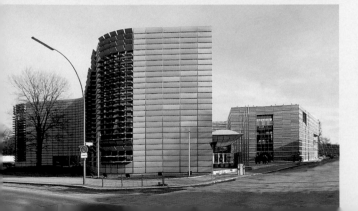

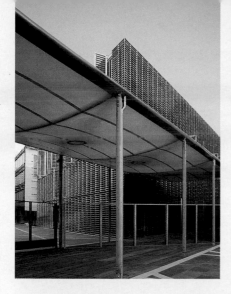

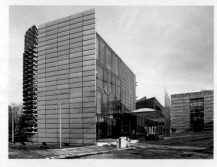

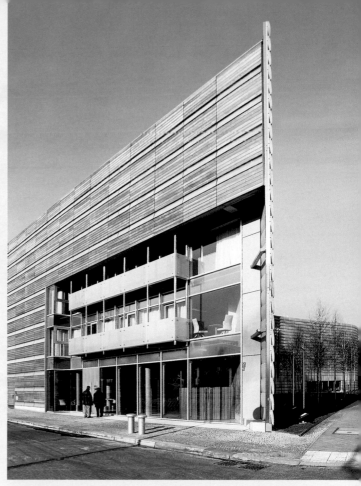

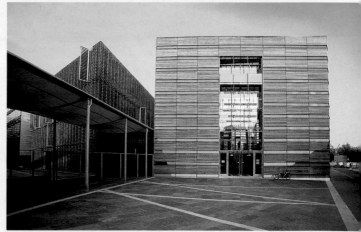

height of 15 meters and weighs 120 tons. This was used for the facade of the Norwegian embassy.

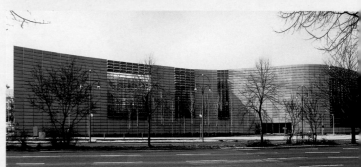

German Standardization Institute
(Budapester Strasse 41)
Architects: Johannes Heinrich, Berlin
1997-99

The German Institute for Standardization was extended by a building on Budapester Strasse. It stands out due to its tower-like structure that is perpendicular to the nave which protrudes somewhat out of the facade.

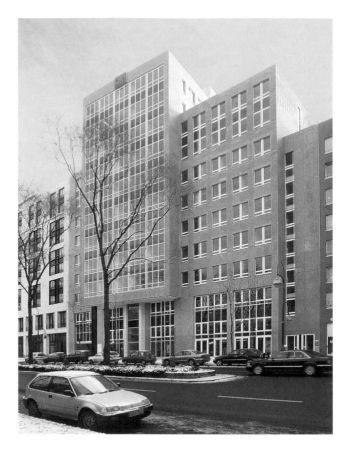

Residential and Commercial Building
(Tauentzienstrasse 7 b/c)
Architects: Eller + Eller, Düsseldorf
1996-99

The cubic, nine story corner building by the architects Eller + Eller is in an exposed position next to the Europe Center. Although the height of the eaves is the same as that of the neighboring building, this structure also has vertical elements such as bay windows. In addition, the ground floors form a large store window while the oriols give the facade a more sculptural design.

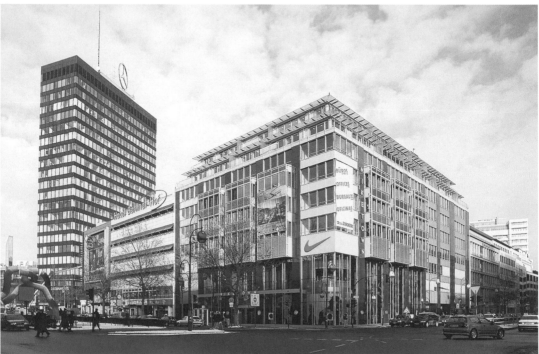

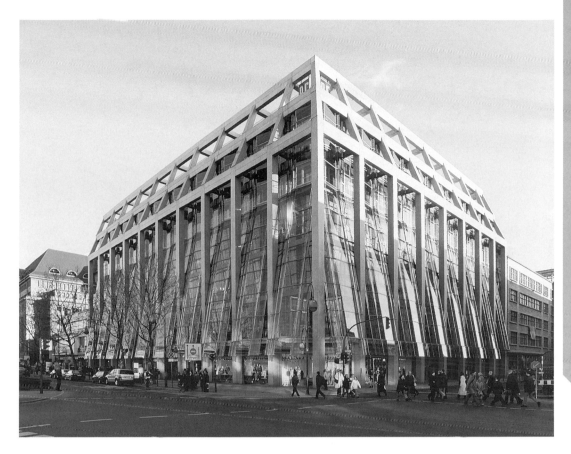

Peek & Cloppenburg Department Store
(Tauentzienstrasse 19)
Architects: Gottfried Böhm, Peter Böhm
1994-96

The Böhm family of architects from Cologne became famous through their modern churches located in the Rhine area. That is why their design for a department store on Tauentzienstraße one of Berlin's most important shopping areas is all the more surprising. The unique architecture consists of an exterior framework composed of concrete pillars and supports. Its hipped roof aligns it with the neighboring building. The actual building has a glass facade, in front of which there is a second glass covering which protrudes from the middle and forms a canopy. This canopy emerges from between the concrete pillars. This glass canopy is draped like a piece of cloth, alluding to the products offered within.

Salamander House
(Tauentzienstrasse 15/Marburger Strasse)
Architects: gmp (von Gerkan, Marg & Partner), Hamburg
1997

The building's exterior creates an unusual effect. Like two other corner buildings which were built by this architect's office, the corner of this building is marked by a tower-like structure. In this case it is a framework structure with the company logo.

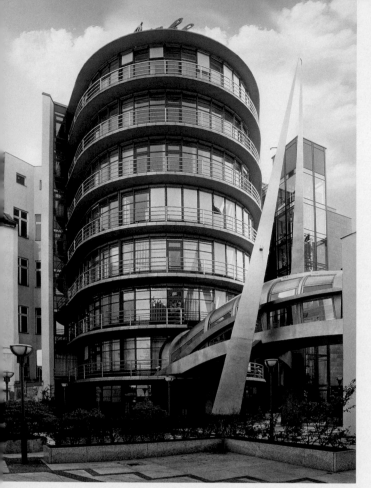

Löbbecke Bank
(Fasanenstrasse 76-77)
Architect: Wolf-Rüdiger Borchardt, Berlin
1992-96
The curved bridge, which links the round
glass building to the old building from
1872-74 was designed by the artist Mona
Fux.

Ku'damm-Eck
(Kurfürstendamm 227-228/Joachimstaler
Strasse)
Architects: gmp (von Gerkan, Marg &
Partner), Hamburg, 1998-2001

In the middle of the western part of the
city stands a building used as a hotel,
department store and picture gallery. Its
rounded and curving shape is adapted to
the building's corner position.

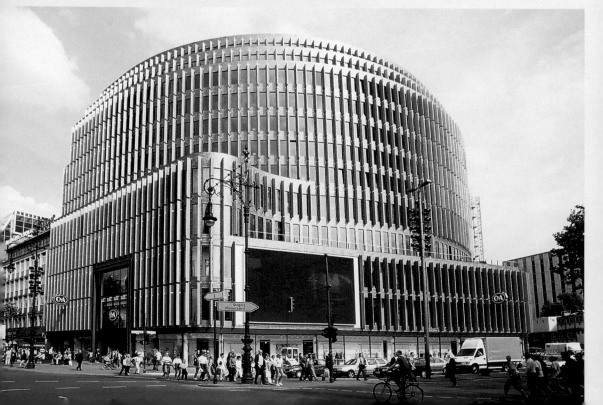

Kranzlereck

(Kurfürstendamm)
Architects: Murphy/
Helmut Jahn
1997-2001

The glass building complex by the German-American architect Helmut Jahn is located between Ku'damm and Zoo railway station at the so-called Kranzlereck (Kranzler's Corner). This building is dominated by a thin 50 meter high glass disk. The complex surrounds the legendary Café Kranzler which is only two stories high. The new glass building was disputed because its size and building materials, glass, steel and concrete, give the Kurfürstendamm a new appearance. The sharp-edged and transparent corners of the building are architecturally unique.

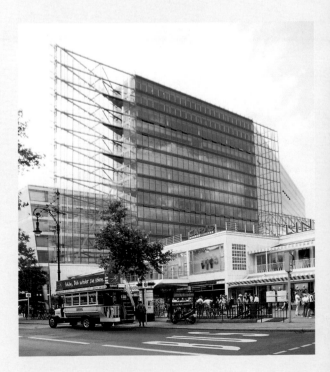

Zoofenster

(Hardenbergstrasse/Joachims-taler Strasse/ Kantstrasse)
Architect: Christoph Mäckler, Frankfurt a. M./Berlin, 1999-2002

The 150 meter high building with apartments on 37 stories is being built between the Zoo railway station and the Kaiser Wilhelm Memorial Church.

Tower at the Kant Triangle

(Kantstrasse 155)
Architect: Josef Paul Kleihues
1992-94

The complex consists of a five story high, wedge-shaped building and a 36 meter high building with a flat tent roof standing on a square ground plan (18 x 18 meters). It is located vis-à-vis the Theater of the West near the Zoo railway station. The building is notable for its prominent "Hahnenkamm", a huge weather vane made out of sheet metal.

illustrations:
Tower at the Kant Triangle

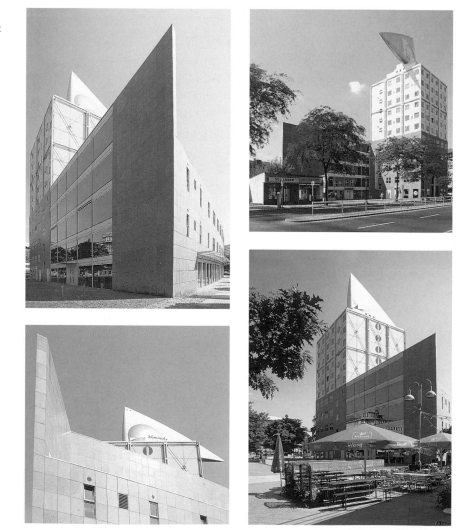

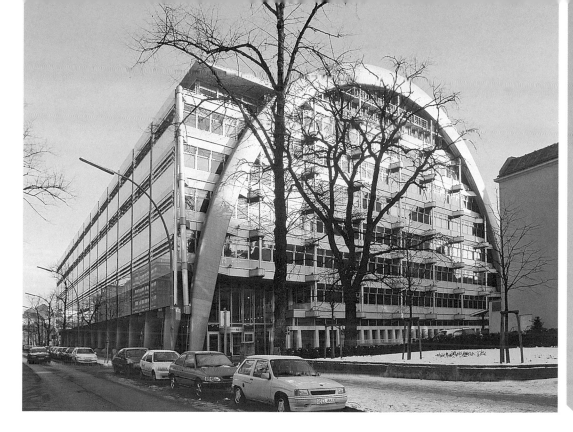

Ludwig Erhard House (Stock Market)
(Fasanenstrasse 83)
Architects: Nicholas Grimshaw & Partners, London/Berlin
1994-98

The Ludwig Erhard House is popularly called "armadillo". This term paraphrases the unusual outline of the steel-glass building which is very unique. 15 steel transverse arches form the constructive framework of the building. They become higher and wider towards the middle of the building in accordance with the width of the plot on which the house is built. This conveys the impression of a scaled, moving body, especially when viewed from the air. The arches form a huge hall without pillars, to which the floors are connected. The facades have technical details with a decorative function. This building was commissioned by the Chamber of Commerce of Berlin, which in addition to the stock exchange also operates a service and communication center.

The British architect Nicholas Grimshaw was born in 1939. He prefers using new

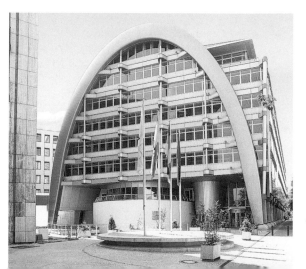

137

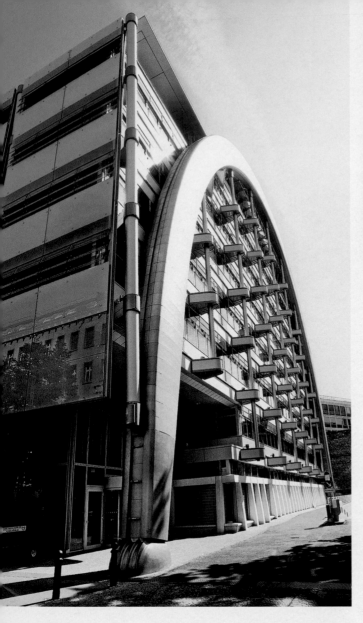

BMW

(Kurfürstendamm/Uhlandstrasse)
Architects: Fischer – Krüger – Rathai,
Wiesbaden
1993-94

The conventional facades of the corner building are covered with sandstone. On the corner there is a glass cylinder, which is used as an entrance for customers.

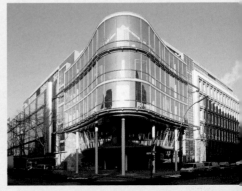

| Ludwig Erhard House | materials such as glass, steel and aluminium. At the same time he tries to combine engineering concepts with harmonic construction. His famous Waterloo Terminal in London (1993) for the Euro Star channel tunnel train is also an example of this. |

stilwerk Design Center
(Kantstrasse 17-20/Uhlandstrasse 9-11)
Architects: Novotny, Mähner & Associates, Offenbach/Berlin; Studio + Patners, Milan
1998-99

The raised entrance is recessed into a two-story vestibule at the corner of the building. The vestibule's glass facade extends in a wide curve into the street.

"Ku' 70"
(Kurfürstendamm 70)
Architect: Helmut Jahn
1993-94

The narrowest office building in Berlin is situated at Adenauerplatz. The small spare plot was left over after urban re-organisation in the 1970's. The ten-storey building of 50 meters hight and 800 square metres was erected on a ground area of 2,5 by 20 meters (60 square metres). Die architect designed a glass-steel construction. The upper storeys which project five metres over the building alignment line form an expressiv steel, aluminium and glass structure. At the roof storeys is a "news" display area which is supplied with text day and night. The corner of flat roof occupies the antenna with the company logo of the building owner.

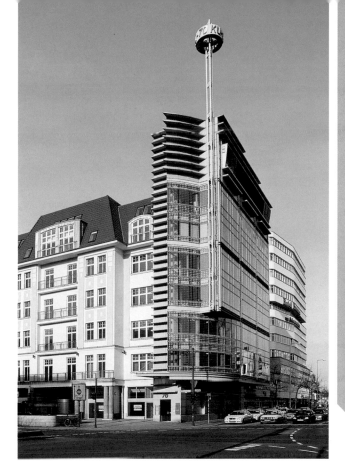

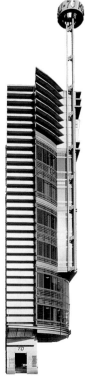

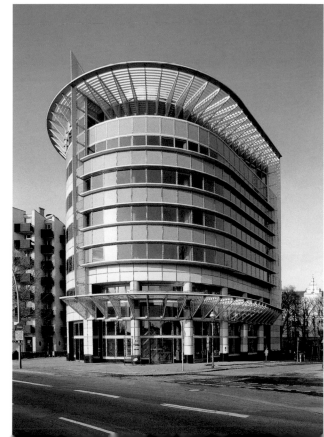

Right:
Kurfürstendamm 119
(text see p. 140)

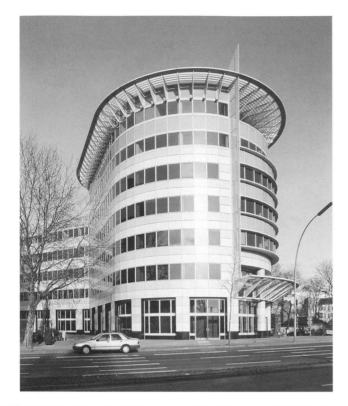

Office and Commercial Building
(Kurfürstendamm 119)
Architect: Helmut Jahn

The round tower-like building on Kurfürstendamm with its open metal roof is the eye-catcher of this huge building complex. In contrast to the other structures built by Helmut Jahn in Berlin, glass does not dominate this building's architecture. In addition, the pointed corners that are typical for his other buildings are missing here. The corners of these blocks are instead rounded off or shaped like round towers. The building also has several rows of windows which divide it into different horizontal sections. The blue reflecting windows are in the same plane as the white to gray-blue layer of facing material. It is only at the round tower of the main entrance that the third to fifth floors protrude oriol-like from the facade and that the windows are accentuated by means of a window sill-like band.

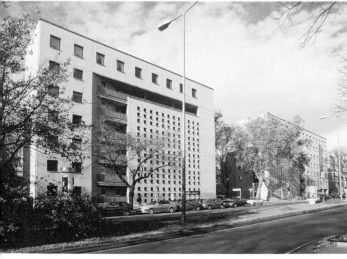

Residential Building
(Tempelhofer Damm 44-46)
Architect: Chestnutt Niess, Berlin
1989-92

The compact and cubic buildings with open slits on the sixth floor are located opposite the Tempelhof Airport. They are designed symmetrically to each other.

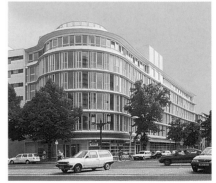

Office Building
(Bismarckstrasse 101)
Architects: Kohn/Pedersen/Fox, London/Chicago
1993-95

The office building located near the German Opera in Berlin-Charlottenburg exudes a certain dynamism due to its round shape. Because of that and its high amount of glass, it contrasts sharply with the neighboring buildings, even though the forms and shapes, such as the hanging roof and the horizontal and vertical sections, remind us of 1950s architecture.

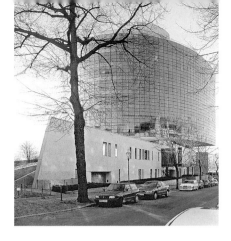

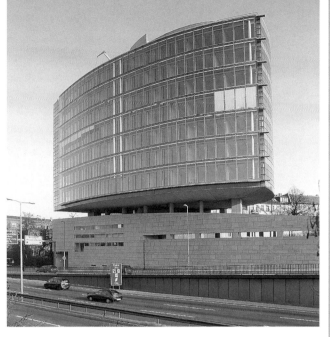

Office Building at Halensee
(Halenseestrasse/Kronprinzendamm)
Architects: Hilde Léon and Konrad
Wohlhage
1994-96

This original and unobtrusive new office
building standing on a narrow plot of
land right next to the highway was
designed by Hilde Léon (born in 1953)
and Konrad Wohlhage (born in 1952).
On a granite-covered base, an outline-
like, seven-story glass building appears
to float upward and expand. Its unusual
shape gave it the nickname "lemon". Its

soundproof facade consists of safety
glass inside and of insulating windows
outside. In between there is a space
84 cm wide.

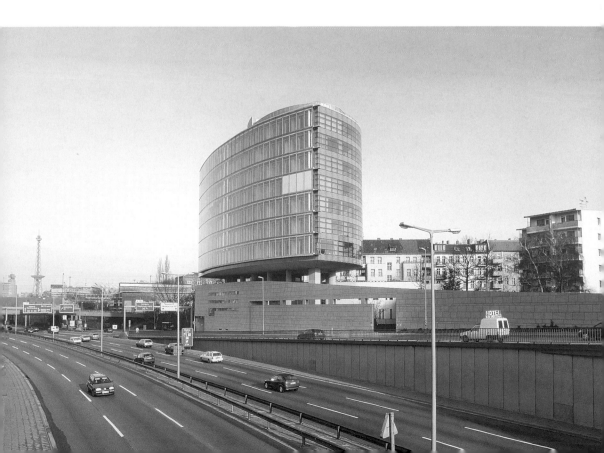

Office and Shopping Building
(Schlossstrasse 40, Berlin-Steglitz)
Architects: Assmann, Salomon and
Scheidt, Berlin
1991-92

The building is erected on a prominent
street corner in the city centre of Steglitz
and looks like a big sculptur. It is formed
by three panels which are disarranged. A
glass-steel construction in the middle is
surrounded by a dynamically oblique and
curved angle.

"Galleria" Shopping Building
(Schlossstrasse 101, Berlin-Steglitz)
Architects: Quick, Bäckmann and Quick,
Berlin, 1993-94

The lens-shaped glass facade which
spans six storeys forms a large display
window.

Office Building (illustration below)
(Carnotstrasse 4-7, Berlin-Charlotten-
burg)
Architekt: Jürgen Sawade, Berlin
1994-96

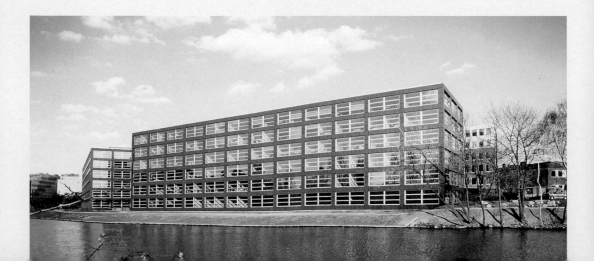

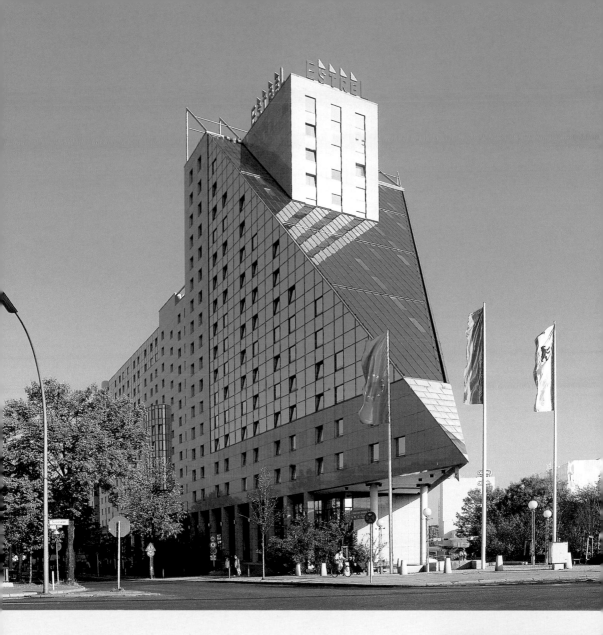

Estrel Residence Hotel

(Sonnenallee 225, Berlin-Neukölln)
architects: Hennes + Tilemann, Bonn
1994-95

The largest hotel in Germany with
1,100 rooms is situated on an oblique-
angled corner on Sonnenallee. The
eighteen-storey building creates a pris-
matic structure to the Sonnenallee.
The point of the building seems to be
suspended. The facades are structured
by the combination of stone facing
and glass facing.

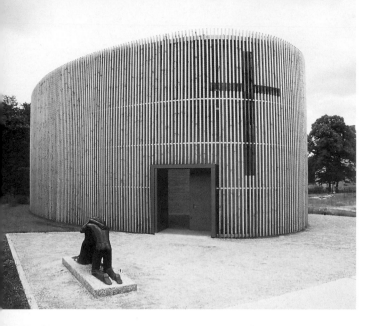

Chapel of Reconcilliation
(Bernauer Straße 4, Berlin-Mitte)
Architects: Reitermann/Sassenroth,
Berlin
1999-2000

The oval shaped building is standing on
the plot of land where the Protestant
Reconciliation Church from 1894 was
standing before it was blown up in 1985.
It was located on the "death strip" of the
Berlin Wall. The loam community buil-
ding, which contains an organ loft and a
single upper window, has an ambulatory
added to the front. Its facade is domina-
ted by a lamella wall. In the back part of
the ambulatory the foundation walls of
the predecessor building is visible
through a small opening in the ground.
Its bells are hanging in a separate bell-
cote on Bernauer Straße.

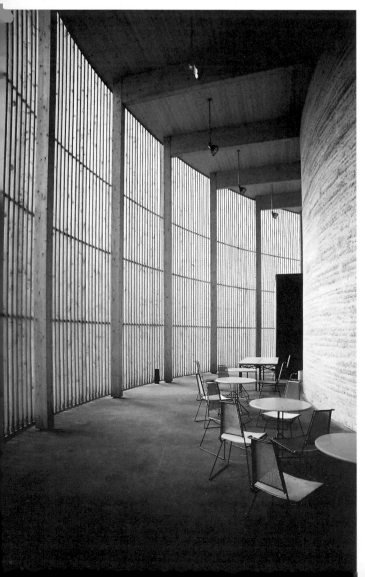

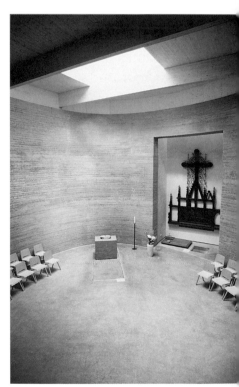

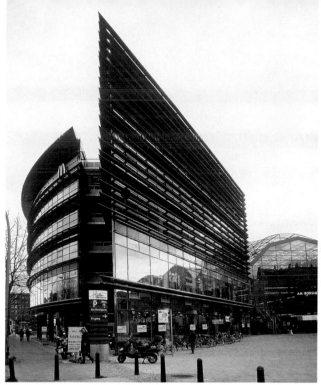

Commercial District "Am Borsigturm"

(Berliner Straße, Berlin-
Reinickendorf/Tegel)
Architects: Start-up Center "Phönix":
Walter Rolfes + Partner, Berlin, 1995-97;
Commercial district: Rolfes + Partner,
Berlin, 1997-98; office complex/hotel: Axel
Schultes, Deubzer and König, Berlin, 1996-
2002; halls: Claude Vasconi, Paris, 1996-99

Spacious apartments, offices, and buildings
were built around the Borsig Tower (1922-
24) according to an urban development
concept by Vasconi (1994/95). They skill-
fully integrate the parts of the former Borsig
Plant. Behind the stretched building along
Berliner Straße there are the rebuilt old Bor-
sig halls. These buildings are steel-glass
constructions by Vasconi (illustration above
right) and are used today as spacious shop-
ping arcades.
Corner towers and bricks characterize the
Phönix- Start-up Center (illustration above
left). Glass and bricks characterize the hotel
and the office buildings situated around the
Borsig Tower (illustration above left bot-
tom).

Commercial Center at the Ullstein House

(Ullsteinstraße, Berlin-Tempelhof)
Architects & Nalbach, Berlin
1991-94

The printing shop built by Eugen Schmohl
was extended by three towers with connec-
ted stair towers and five story high trading
halls. The new buildings have the same
proportions as the old one had. Its concrete
ashlars which are dyed red form a contrast
to the red bricks of the old building.

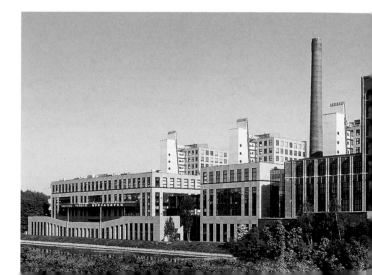

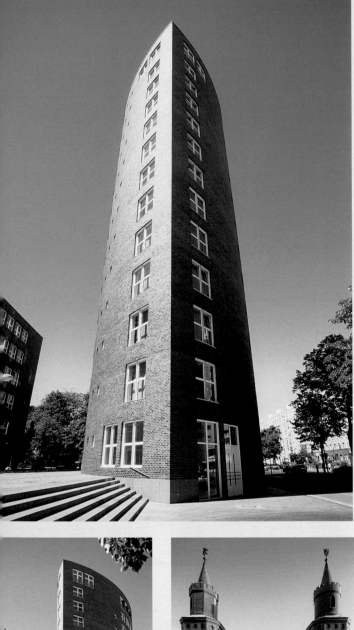

Residential and Commercial Buildings
(Brunnenstrasse 111, Berlin-Wedding)
Architect: Josef Paul Kleihues, Berlin
1995-98

Kleihues constructed buildings on the northeastern part of the AEG area on Brunnenstreet. There he built the 13 storey high almond-shaped tower which is an architectural masterpiece.

Media Port (ill. above right)
(Voltastrasse 6, Berlin-Wedding)
Architect: Josef Paul Kleihues, Berlin
1994-96

The building for the Deutsche Welle radio station is built symmetrically. The middle is dominated by a 45-meter high brick building.

Oberbaum Bridge
(Stralauer Allee/Oberbaumstrasse, Berlin-Friedrichshain)
Architects: Santiago Calatrava, Zürich; König, Stief & Partner GmbH, Berlin
1992-95

This bridge constructed from 1894-96 was rebuilt from 1992 to 1995. The middle section was newly designed by Calatrava.

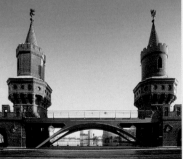

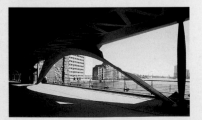

Max Schmeling Hall
(Friedrich-Ludwig-Jahn-Sportpark, Berlin-Prenzlauer Berg)
Architects: Joppien Dietz Architekten, Berlin/Frankfurt/M.
1993-96

Next to the former death strip of the Berlin Wall a multipurpose building was constructed as a sport and recreation center in the Friedrich Jahn Sports Park. It is named after the boxer Max Schmeling and was built on the occasion of Berlin's application for the Olympic Games in 2000. A large part of the facility is located below a hill, an expanse of rubble from the Second World War. The hall consists of a main sports arena (30 x 50 m) and three additional halls (27 x 45 m each) in the lower wings at the sides of the building. 10,000 visitors fit into the hall which has 7,600 seats.

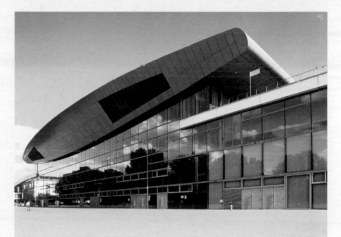

Oberbaum City
(Warschauer Platz/Rotherstrasse, Berlin-Friedrichshain)
Architects: Schweger + Partner, Hamburg/Berlin; Reichel & Stauth, Braunschweig; Schuh & Hurmer, Munich
1993-2001

The buildings of the former Deutsche Glühlicht AG (later Osram or VEB Glühlampenwerk/Narva) was converted into a modern commercial and service center. The original tower had a five-storey steel-glass structure.

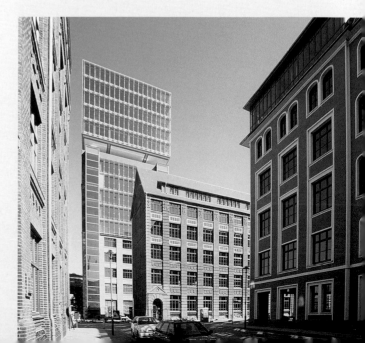

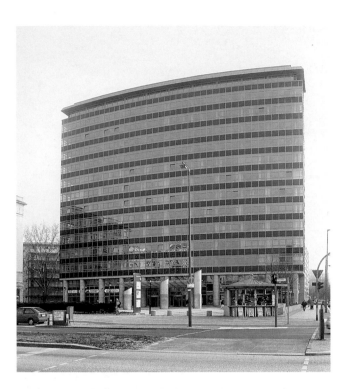

Office Building on Karl-Marx-Allee
(Karl-Marx-Allee 90/Strasse der Pariser
Kommune, Berlin-Friedrichshain)
Architects: Wörle & Partner, Munich
1995-97

The horizontally arranged high-rise buil-
ding stands parallel to the Karl-Marx Allee
and is located some distance away from
the street.

Office and Commercial Building
(Frankfurter Allee 69/Voigtstrasse 1,
Berlin-Friedrichshain)
Architects: Takamatsu + Lahyani GmbH,
Kyoto/Berlin
1993-94

The choice of materials and the "playful"
architectural elements help accentuate
this corner building located along Frank-
furter Allee. At first sight the polished
black granite facing, the panes, and the
four futuristic glass tubes in the upper
stories above the entrance appear to be
sumptuous and spacious.

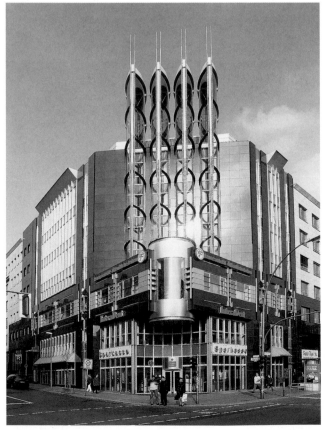

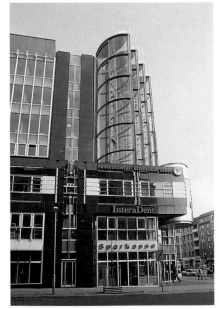

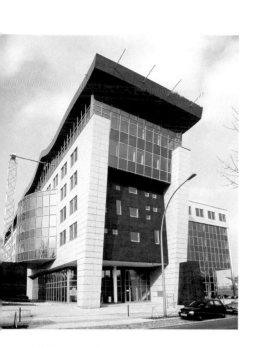

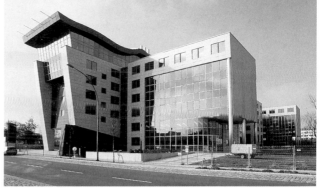

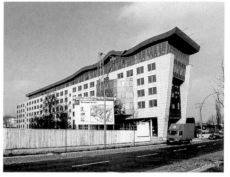

Office Complex
(Bornitzstrasse, Berlin-Lichtenberg)
Architects: Kahlen and Partner, Berlin
1994-99

The six-storey high office center in Berlin-Lichtenberg stands out due to its diverse forms of architecture.

Ostkreuz
(Schreiberhauer/Kaskelstrasse, Berlin-Lichtenberg)
Architects: J.S.K. Architekten, Berlin
1996-99.

One of the largest service centers of Berlin was built around the suburban train station Ostkreuz. However, it does not have many spectacular buildings. An exception is the design by the architects J.S.K. Perkins & Will of a bent 13-storey high-rise building. It follows the course of the train track and its exterior walls, which are flat and uniformly arranged, consist of glass and aluminium. An aluminium-brick facing was used by the architects for the eight-storey building on Scheibenhauerstraße.

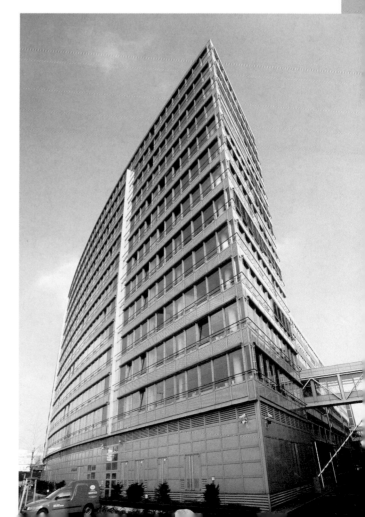

Apartment Houses

(Nöldnerstrasse 1, 6-7, Berlin-Lichtenberg)
Architect: Werner Wöber, Wien
1996

The manycoloured walls are disarranged and dynamically oblique. Therefore the buildings of the Nöldnerstrasse look very stange.

Rummelsburg Bay

The Rummelsburg area (south-east of Berlin-City-Center) is one of Berlin's main development sites. During the GDR years Rummelsburger Bucht was used by industries. The ground and the water were polluted. The land was cleaned up after all industrial production was closed down in the year 1990.

The area was envisaged as an Olympic village in Berlin`s unsuccessful bid to stage the Olympic Games in the year 2000. Klaus Theo Brenner and the landscape architects Duquesnoy and Thomanek designed the new „urban landscape". 5,900 dwellings, 425,000 square meters of office and commercial space, two schools and six children's daycare centers are to be completed here.

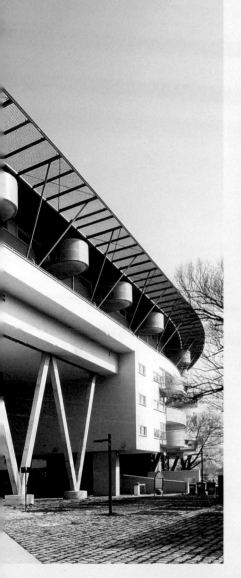
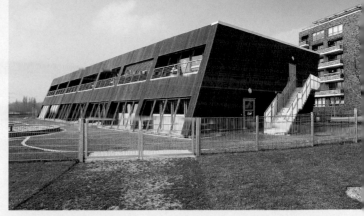

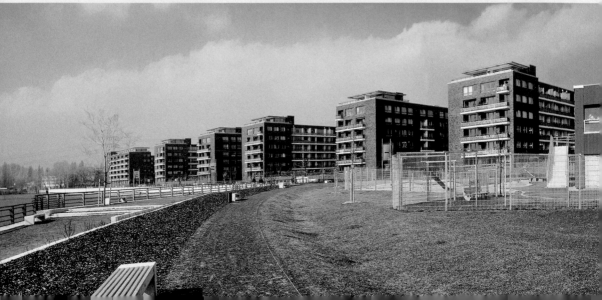

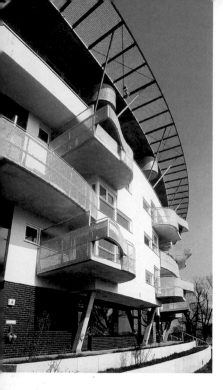

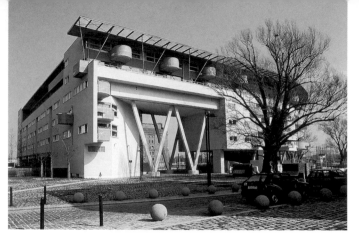

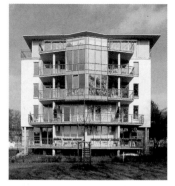

Above, left and below: Building by Herman Hertzberger

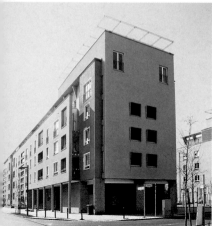

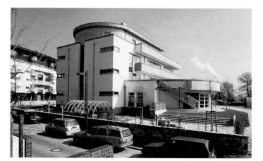

**Wasserstadt
(water village)
Rummelsburger
Bucht**

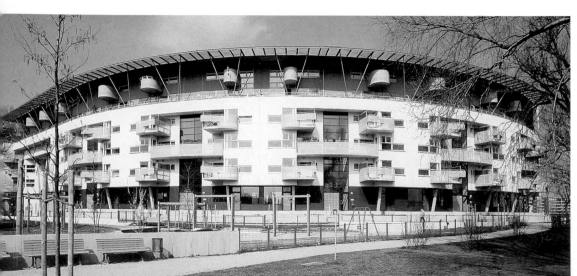

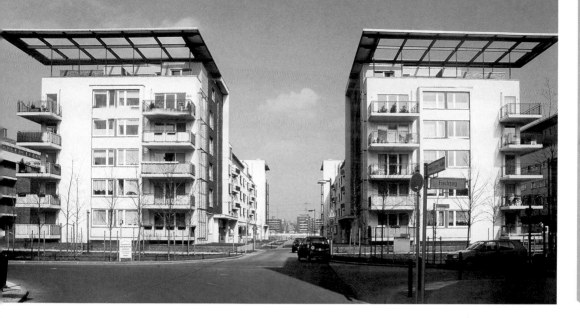

Wasserstadt (water village) Rummelsburger Bucht

Twin Towers
(Hoffmannstrasse/Eichenstrasse, Berlin-Treptow)
Architects: Kieferle & Partner (Georg Kieferle, Eberhard Bender and Cornelia Kieferle-Nicklas), Stuttgart
1995-98

The Twin Towers are right next to the Treptower. These are two high-rises which face each other. The 17-storey high buildings are identical to each other and form a mirror image. The towers show great variety in their design, sporting staircases on the sides, numerous bays and recesses and perforated hanging roofs. The top floors of the buildings point toward each other. The towers are connected to each other by a pedestal which is three stories high and faced with natural stone. Two additional office buildings belong to the Twin Towers. Both have a square shaped inner courtyard.

Treptower
(Hoffmannstrasse/Elsenstrasse, Berlin-Treptow)
Architects: Gerhard Spangenberg, Berlin; Reichel & Stauth, Braunschweig; Schweger + Partner, Hamburg/Berlin
1995-98

The highest office building in Berlin belongs to a new service center. It is located at the Spree River and is near the Treptower Park railway station. The building can be seen from a long distance away. The tower by the architect Spangenberg from Berlin is 30 stories high. The lower part of the building has a cube shaped stone facade with a grid-like structure. The building is of steel-glass construction on the other floors. The tower has been successfully integrated into the smaller surroundings that is accentuated by different colors. The complex integrates the buildings of the former AEG, which were built from 1928 to 1938 according to plans by Ernst Ziesel. In the GDR these buildings

were used by Elektro Apparate Werke EAW. The three gigantic apartment houses by the Hamburg architect Schweger stand diagonally to the Spree. Since their design and their coloring is pretty monotonous, they appear to be rather unspectacular.

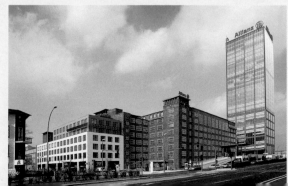

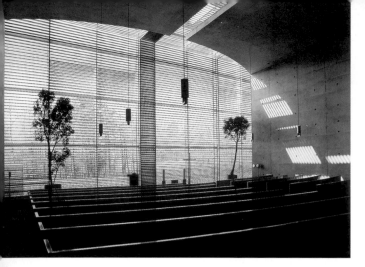

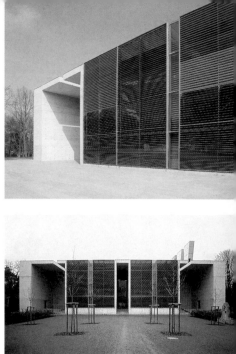

Baumschulweg Crematorium
(Baumschulweg, Berlin-Treptow)
Architect: Axel Schultes, Berlin
1996-98

Cubic and clear forms and exposed
concrete characterize the exterior of the
building. With its many columns and
light effects the interior seems very
mystical. Round openings located above
the 29 exposed concrete pillars that carry
the roof make the columns appear like
burning candles. A curious light effect
can also be found in the three celebration
halls (illustration above left).

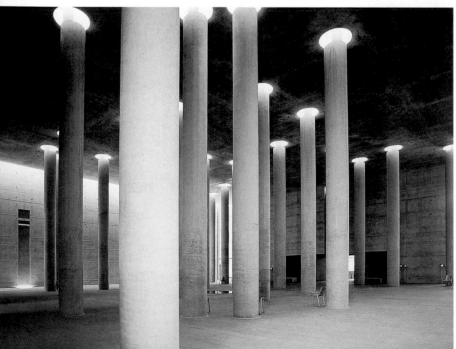

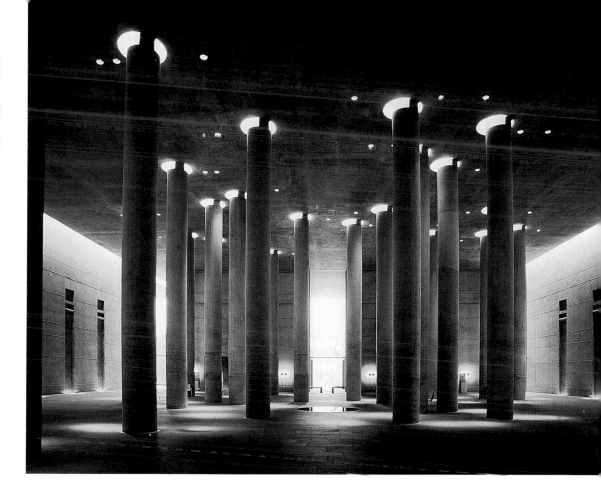

Wohnhaus
(Radickestrasse 7, Berlin-Treptow)
Architekt: Georg Ritschl, Berlin
1995

Business-Center auf dem WISTA-Gelände
(Wirtschafts- and Wissenschaftsstandort
Berlin-Adlershof)
(Rudower Chaussee 5, Berlin-Treptow)
Architekt: Dörr-Ludolf-Wimmer, Berlin
1996-97

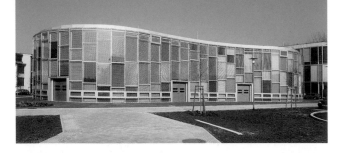

Innovation Center for Photonics

(Gewerbe- und Wissenschaftsstandort
Adlershof, Rudower Chaussee 6, Berlin-
Treptow)
Architects: Matthias Sauerbruch, Louisa
Hutton, London/Berlin
1996-98

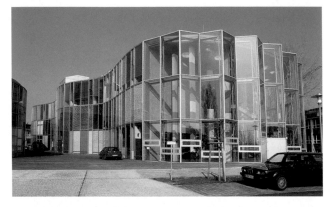

The flat-roofed glass buildings of the Pho-
tonics Innovation Center (a laboratory for
optics and laser technology) are among
the most unusual and esthetically appea-
ling new structures in Berlin. The center
is located in the southeastern part of
Berlin.
Because of the round shape of the
ground plan, the two buildings are called
the "amoeba". It is also unusual that one
of the buildings with windowless interior
rooms (for the laboratory) has a com-
pletely glazed and transparent outer wall.
The window panes allow a glimpse into

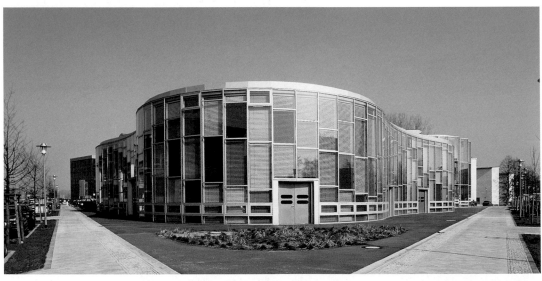

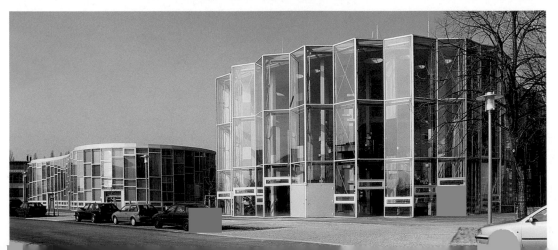

the interior, which is very colorful. The blaze of color and the venetian blind-like sun protection in 39 different colors give the transparent facade its colorful appearance. This makes it similar to the GSW high-rise building which was also designed by Sauerbruch & Hutton. The architects also used a glazed double-layered facade here. It allows the rooms to be ventilated and cooled in an environmentally-friendly manner.

Bibliography

Architektur in Berlin, Jahrbuch 1993/94ff. (hg. v. d. Architektenkammer Berlin).
Bauwelt Berlin Annual (Chronik der baulichen Ereignisse 1996 bis 2001), Bd. 1 1996, Bd. 4 1999/2000, Basel/Berlin/Boston 1997-2000.
Behr, Adalbert: Bauen in Berlin 1973-1987, Leipzig 1987.
Berlin – Offene Stadt. Die Stadt als Ausstellung (hg. v. d. Berliner Festspielen und der Architektenkammer Berlin), Berlin 1999.
Berning, M.; Baum, M.; Lütke-Daldrup, E.: Berliner Wohnquartiere. Ein Führer durch 60 Siedlungen in Ost und West, Berlin 1994.
Dollé, M. (Hg.): Der Campus. Ein Führer durch das Gelände der HDK und der TU, Berlin 1994.
Demokratie als Bauherr. Die Bauten des Bundes in Berlin 1991-2000 (hg. v. Bundesministerium für Verkehr, Bau- und Wohnungswesen), Berlin 2000.
Burg, A.: Architekten Kollhoff und Timmermann, Basel/Berlin/Boston 1998.
Cullen, M. S.: Der Reichstag. Parlament, Denkmal, Symbol, Berlin 1995.
Dorner, E.: Daniel Libeskind. Jüdisches Museum Berlin, 2. Aufl. Berlin 2000.
Dudler, M.; Pauser, W.: Schulbau in Berlin-Hohenschönhausen, Berlin 1999.
Gemäldegalerie Berlin. Der Neubau am Kulturforum, Berlin 1998.
Gerkan, Meinhard von: Architektur für den Verkehr, Architecture for Transportation. Von Gerkan, Marg und Partner, Basel/Berlin/Boston 1997.
Haberlik, C.; Zohlen, G.: Die Baumeister des Neuen Berlin. Porträts, Konzepte, Berlin 1997.
Hauptstadt Berlin. Berlin. Denkmalpflege für Parlament, Regierung und Diplomatie 1990-2000 (= Beiträge zur Denkmalpflege in Berlin 16, hg. v. Landesdenkmalamt Berlin), Berlin 2000.
Jenner, M.: Neue Britische Architektur in Deutschland, München 2000.

Kapitzki, C.: Berlin – Versionen werden Realität, Berlin 1998.
Kieren, M.: Neue Architektur, Berlin 1990-2000. New Architecture, Berlin 1990-2000 (hg. v. Förderverein Deutsches Architektenzentrum Berlin), Berlin 1997.
Kleihues, J. P. (Hg.): Bauen in Berlin 1900-2000, Berlin 2000.
Kleihues, J. P. (Hg.): 750 Jahre Architektur und Städtebau in Berlin. Die Internationale Bauaustellung im Kontext der Baugeschichte Berlins, Ausstellungskatalog Neue Nationalgalerie Berlin 1987, Stuttgart 1987.
Mesecke, A.; Scheer, T. (Hg.): Josef Paul Kleihues. Themen und Projekte. Themes and Projects, Basel/Berlin/Boston 1996.
Meyer, U.; Hoffmann, H. W.: Bundeshauptstadt Berlin. Parlament, Regierung, Ländervertretung, Botschaften, Berlin 1999.
Die Neuen Architekturführer (Stadtwandel Verlag, Berlin); zahlreiche Ausgaben zu Neubauten in Berlin.
Pabsch, M.: Zweimal Weltstadt. Architektur und Städtebau am Potsdamer Platz, Berlin 1996.
Der Potsdamer Platz. Geschichte, Wettbewerb, Neugestaltung, Berlin 2000.
Redecke, S.; Stern, R.: Foreign Affairs. Neue Botschaftsbauten und das Auswärtige Amt in Berlin, Basel/Berlin/Boston 1997.
Sauerbruch, Hutton, Projekte 1990-1996, Basel/Berlin/Boston 1996.
Senatsverwaltung für Bau- und Wohnungswesen (Hg.): Projekte für die Hauptstadt Berlin, Städtebau und Architektur, Bericht 34, 1996.
Stimmann, H. (Hg.): Berlin-Mitte. Die Entstehung einer urbanen Architektur, Berlin 1995.
Oswald Mathias Ungers, Bauten und Projekte 1992-1998, Stuttgart 1998.
Welch-Guerra, M.: Hauptstadt Einig Vaterland. Planung und Politik zwischen Bonn und Berlin, Berlin 1999.
Zohlen, G. (Hg.): Berlin – Offene Stadt. Die Erneuerung seit 1989, Berlin 1999.

Michael Imhof:
**Berlin
Guide to the new Capital**
16,5 x 24 cm, 64 p., 250 ill.
ISBN 3-932526-75-9

Michael Imhof: Berlin. Architektur 2000 Übersicht, 16,5 x 24 cm, 16 S., 60 ill., ISBN 3-932526-64-3